Textile Folk Art

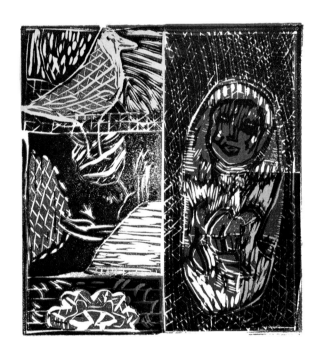

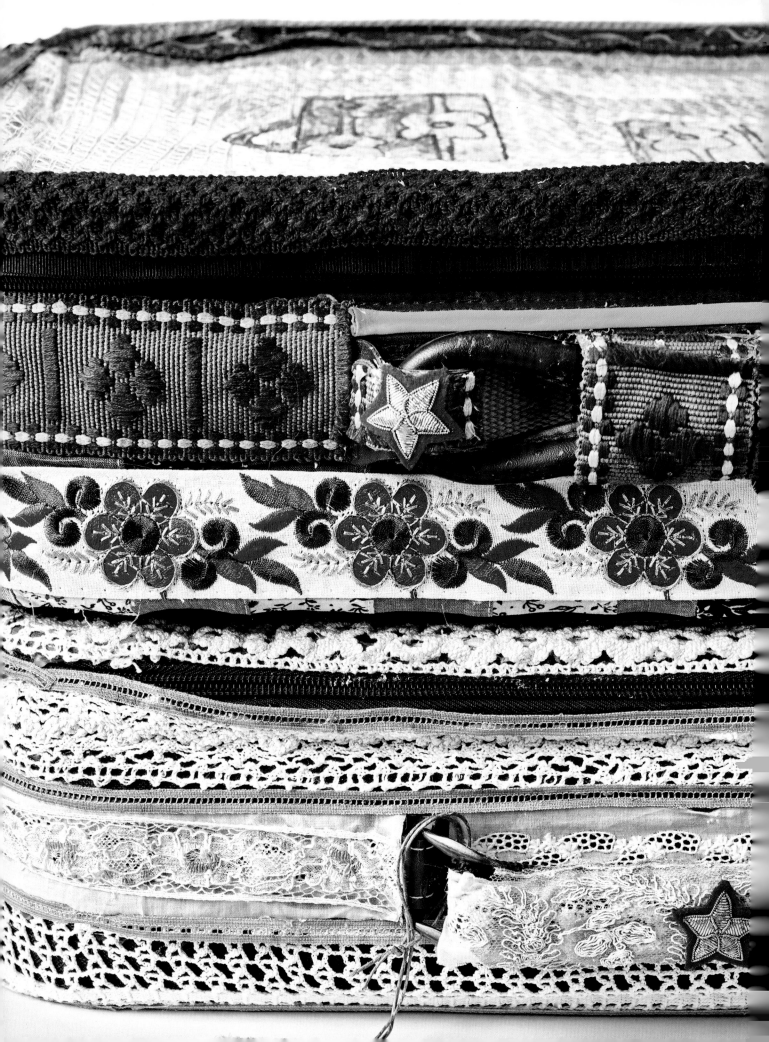

Textile
Folk Art

Anne Kelly

BATSFORD

Acknowledgements

Thanks to all the artists, makers and students named in the text for their contributions. Their details are in the Featured Artists section of the book (see page 122).

Many thanks to photographer Rachel Whiting, and Tina Persaud and Kristy Richardson at Batsford for their support for this project.

My family and friends make everything possible.

First published in the United Kingdom in 2018 by
Batsford
43 Great Ormond Street
London WC1N 3HZ

An imprint of Pavilion Books Company Ltd

ISBN: 9781849944588

A CIP catalogue record for this book is available from the British Library.

25 24 23 22 21 20 19 18
10 9 8 7 6 5 4 3 2 1

Reproduction by Mission, Hong Kong
Printed by Toppan Leefung Printing Ltd, China

This book can be ordered direct from the publisher at the website: www.pavilionbooks.com, or try your local bookshop.

Distributed in the United States and Canada by
Sterling Publishing Co., Inc., 1166 Avenue of the Americas,
17th Floor, New York, NY 10036

Page 1: *Brighton*, coloured lino cut on paper.

Page 2: Detail of *Suitcases*, mixed-media textiles (see pages 60–61).

Right: Detail from a mixed-media textile folding book.

Contents

Introduction 6

Samplers in Stitch 8

Nordic Notes 30

The Silk Road
– Travel and Memory 50

Small Worlds 72

Home and Childhood 92

Conclusion 120
Featured Artists 122
Folk Art Collections,
Museums, Institutions
and Organisations 123
Further Reading 124
Suppliers 125
Index 126
Picture Credits 128

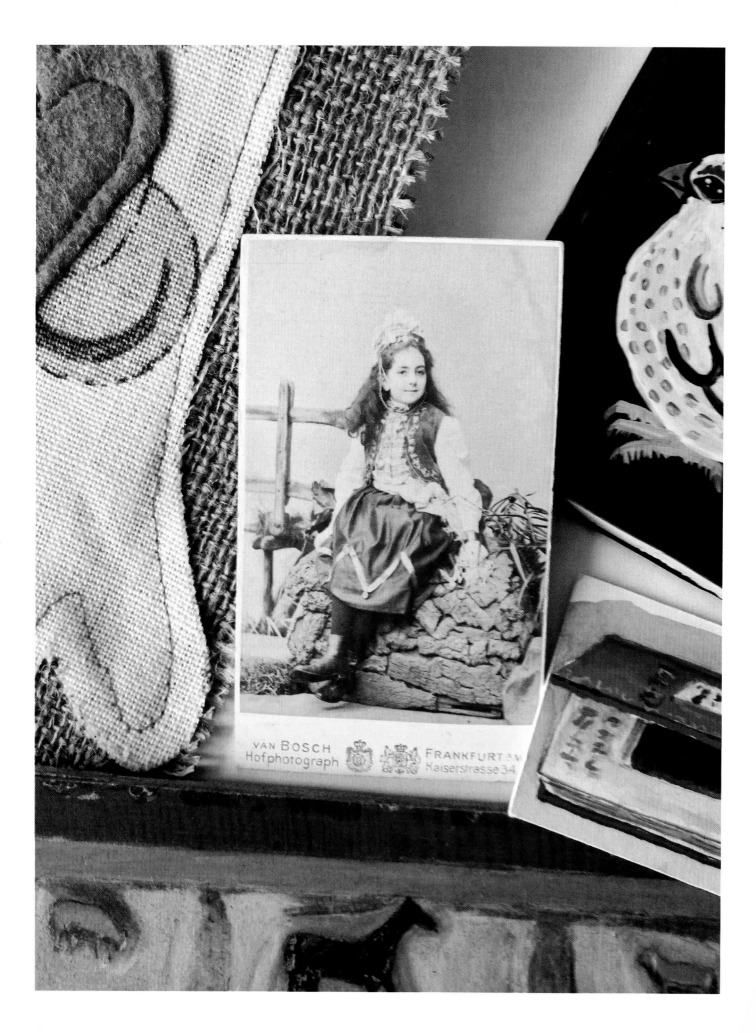

Introduction

I can see my grandmother, aged around six or seven, sat posing for the camera wearing her German folk costume. It is ironic as she was from a Jewish family, but it provides a touching and treasured vignette from over 100 years ago. The object is a small sepia-toned photograph mounted on card by the photographer. The photo represents much of what we can relate to as 'folk art' and has itself become a work of art.

'Folk Art' is a broad term, used to describe work by makers with no formal art training. It represents nationality and locality together and is universal. In this book, I will introduce ways for textile artists to make connections with traditions outside their experience, as well as inside their own family histories. There is a paradox at the heart of this work as I have found that the very simplicity of it enables the viewer to make connections and imbue it with meaning.

The book begins with Samplers in Stitch (see page 8), and looks at simple stitched panels, handmade mementoes and souvenirs. It will show how to make a stitched travel box, and explores the work of artists who use samplers as an element in their work. Samplers can also be statements and records of women and children, recording their personal histories and lives.

Chapter two (page 30) takes us on a journey north with Nordic Notes – reflecting the current trend and interest in all things Scandinavian. Here we will look at traditional Nordic embroidery, designers and makers. Screen-printing and embroidery techniques are explored, as is work by contemporary makers from the UK and abroad.

The Silk Road – Travel and Memory (page 50) examines the influence of the textiles of nomadic people, such as the Mongolians and native Australians, on current designers and makers. Work from India is also included, being very much in the folk-art tradition. This chapter would not be complete without considering luggage and luggage labels, and there is a project for making a folded book – the ideal format for keeping a record of a journey.

Small Worlds (page 72), focuses on intricate and small-scale work. The Tree of Life, a common symbol in many cultures, is the perfect subject for a fabric collage on a small scale, perhaps undertaken as a first project. This chapter also looks at badges, and then we scale things up with a few larger, but still intricate pieces.

Above: Detail from *Horse and Bird*, mixed-media textile.

Left: The author's grandmother, photographed in Germany in the late 19th century.

The final chapter, Home and Childhood (page 92), explores the connection between home and folk art. Traditional American quilts form the starting point and from there we move on to contemporary interpretations. Childhood memories are evoked with a section on dolls' houses and their embellishment.

My aim in writing this book is to illuminate a rich vein of inspiration for textile artists. It is a logical progression from my book *Textile Nature* and links elements from that title and my first co-written work, *Connected Cloth* (see Further Reading, page 124), with some new ideas and references. I hope that the readers and artists who use it will create their own small worlds.

Samplers in Stitch

"Tis the gift to be simple, 'Tis the gift to be free.'

Shaker hymn

Sampler, embroidery on calico,
Cockermouth, UK, from the collection
of Barbara and Heather Gratton.

Samplers and Stitched Panels

Samplers and stitched panels are the first introduction many people will have to textiles. Practicing stitches and putting them together in one piece or project is a satisfying way to capture the essence of sewing. The great tradition of English and North American samplers tells us much about their creators and the lives they led. Dates, including birthdays and locations help to identify their often young and inexperienced makers. Family pets, houses, plants and trees all enrich the surface design. These are often treasured heirlooms that can be handed down to, and enjoyed by, new generations.

A fascinating collection at the Fitzwilliam Museum in Cambridge, Sampled Lives, showcases the variety of subject matter, purpose and design of English samplers. Dating from as early as the 17th century, these were used to record individual lives, families, villages and even schools. With Mary Derow's sampler from St Clement Danes School (shown opposite), we see in a nutshell the depth and breadth of experience that these precious fabric mementoes represent. Mary was a student at the school that still exists in London's Covent Garden, and her work was presented to the board of trustees for sale to raise funds for scholarships to the school. The piece is a sampler worked in silks containing repeat border of patterns, including coronets, alphabets, numerals, an inscription and detached motifs. Mary was ten when she completed it in 1723.

Left: Student work from a Stitch Samplers Workshop, mixed-media with block printing and hand stitching.

Above: *Simple Heart* by Helen Ott, a work in progress, mixed-media textile.

Right: Sampler by Mary Derow (1723). A band sampler in linen and silk, bequeathed by J.L.W. Glaisher to the Fitzwilliam Museum, University of Cambridge.

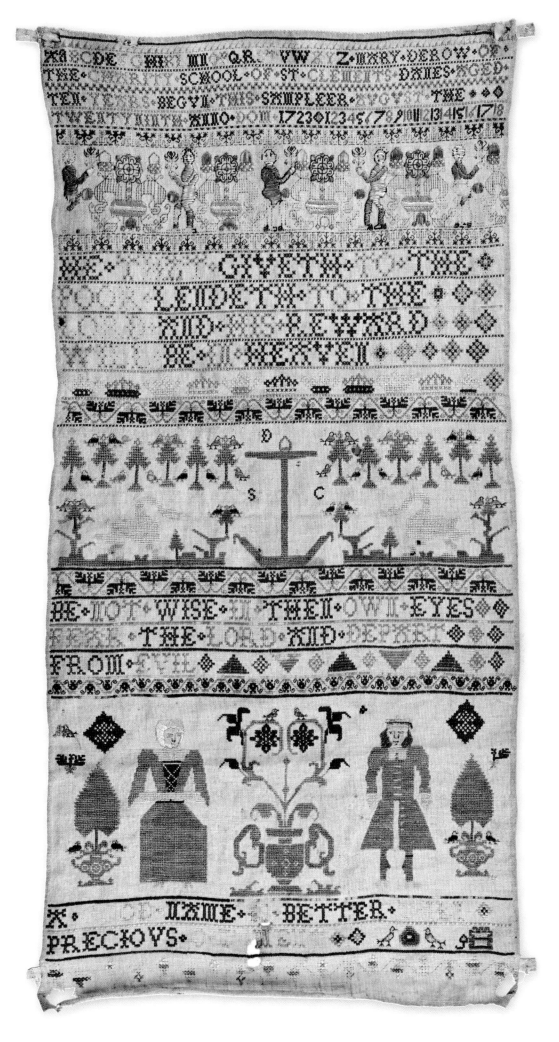

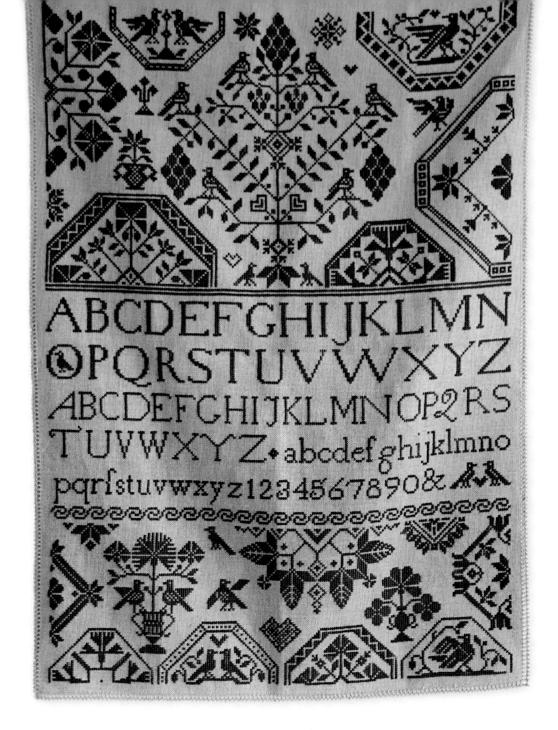

The Little Bird Quaker Sampler by Jacob de Graaf, mixed-media embroidery on canvas.

Modern Folk Embroidery was started by Jacob de Graaf, a Dutch artist living and working in the UK. From his Yorkshire studio, he sells original patterns and materials inspired by centuries of arts and crafts. He uses the visual language of crafters that have gone before him as a creative springboard. His designs have appeared in international publications and are distributed all over the world. His fascination with samplers started when he accidentally found a Quaker sampler in an antique shop – it was a happy find as the piece was from 1795. He has since discovered more about its maker.

For *The Little Bird Quaker Sampler* (above) all the elements seen are original designs, including the traditional-looking medallions and lettering that Quaker samplers are known for. Many Quaker samplers feature birds and elements of the natural world. For this sampler, Jacob wanted to focus on the theme of birds. As he finished the design and counted the number of birds – there are 22 – he remembered that this number is also known as 'two little ducks'.

Hen's Teeth Art

A modern approach to making a sampler could be something altogether freer. Viv Sliwka is a Staffordshire-based artist, making work under the name of Hen's Teeth Art. She says, 'I work spontaneously, reacting to the inspiration provoked from folk art, dogs, hares, flowers and birds ...' Viv always starts the process with drawings and these are translated into print, paint, free-motion embroidery and hand stitch. As Viv says, 'my completed pieces tell tiny tales'. Her work is naïve in style and clearly influenced by folk art. Her colours and imagery are simple but strong, 'I am not one for meticulous planning when it comes to making my pieces ... I have an idea and tend to go with it and see where I end up.' Viv's use of old postcards and envelopes is effective and with her combination of fabric elements they provide a rich background upon which to embellish.

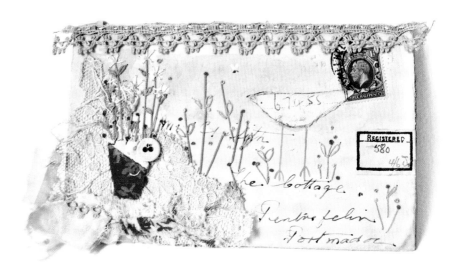

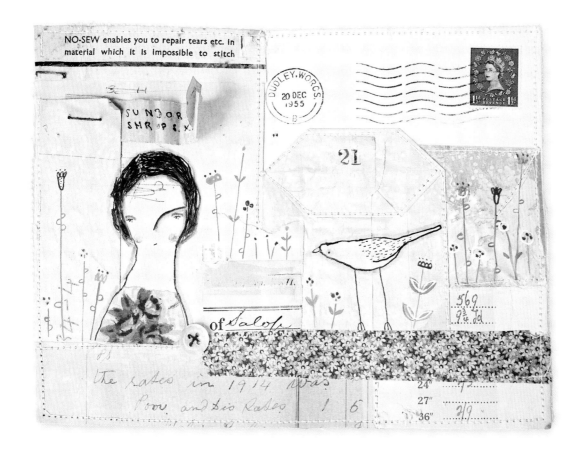

Envelope (above) and *Envelope* (left) by Viv Sliwka. Mixed-media textile with paper, lace, postage stamps and buttons.

Travel Box

Recently in my textile practice, I have been covering wooden objects with a mixture of paper and fabric, as in my *Ark* series (see page 26) and *Stitched Shed* (see page 119). In my teaching experience, I find that students also like to present their work in new and different formats, mounted on wood and in box frames. The travel tags, shown inside the box below, were made for my project *Moving Memories* (see page 60) and provide another intriguing form of presentation.

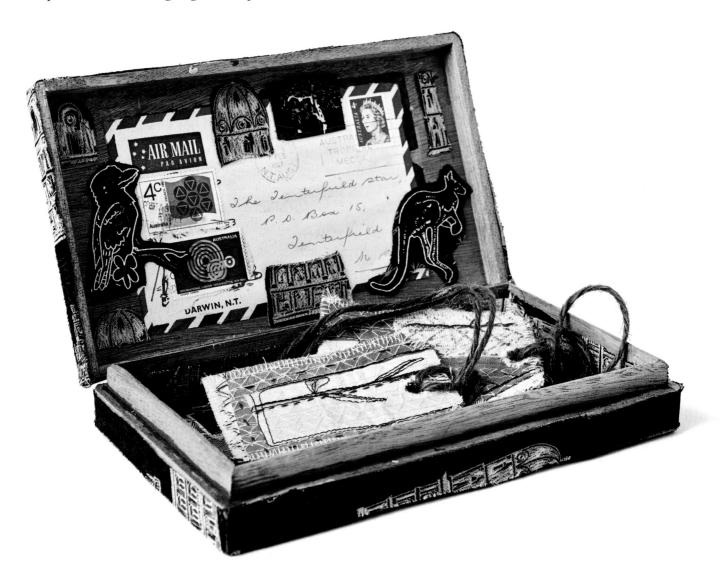

Travel Box, showing the interior with tags. Mixed media on wood with paper, postage stamps and textiles.

I liked the idea of a travel box and I decided to use a small cigar box that I found in a charity shop to commemorate my visit to Australia. I have also inserted pieces of vintage embroidery and used fabric to cover the box. The project opposite demonstrates how you can mix and combine paper and fabric to cover a found item like this box. The final step is to embellish it with writing, postage stamps, small buttons and ribbon and then apply a protective layer of varnish.

Making a Travel Box

MATERIALS AND EQUIPMENT

» Small wooden box, which you can paint or re-cover, like a cigar or sweet box

» Paper, postage stamps, ribbon, buttons, pieces of fabric, embroidery or patches that you wish to use to decorate your box

» Paper scissors and fabric scissors

» Paper-cutting knife and cutting board

» Glue stick, or acrylic wax, if desired

» PVA glue and water mixture or water-based varnish (matt or silk finish)

1 Before decorating the box, make sure that any traces of old paper or unwanted labels are removed.

2 Decide how many surfaces will need to be covered and assemble the paper elements accordingly.

3 Using a glue stick, secure the paper elements to the box and trim with a cutting knife where necessary.

4 Add the pieces for the top and the inside of the lid, and the inside of the box. Buttons and ribbon can be added at this stage if you feel they suit the theme of your box.

5 When everything is in the correct position, varnish box with a mixture of 50 per cent PVA glue to 50 per cent water – you will need two or three coats of the mixture. Acrylic wax can also be applied to the paper elements of the background.

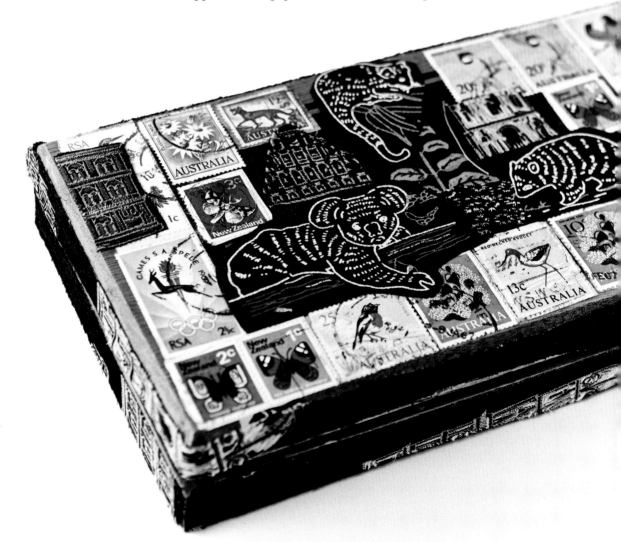

Travel Box exterior, mixed media on wood with paper, postage stamps and textiles.

Lettering

Handmade signs and lettering add a folksy and naïve quality to textile work. This can be seen in the sample of handmade banners from Sussex Prairie Garden (shown below). They were designed and made by the owner, Pauline McBride, and are used and reused for a variety of events and general signposting in the garden.

Wall hangings, mixed media on textile by Pauline McBride.

If you look closely at the lettering on samplers of all kinds you can see some detailed and inventive script. This is often also a feature of contemporary textile art. The shape and formation of letters can be inspiring and representative of other forms in the piece. Often beginners and newcomers to stitch practice their work using the motif of letters.

Typography inspiration from the author's collection, including books, a handmade lithographic booklet and buttons.

Lettering Sampler

I am inspired by lettering in stitch and wanted to celebrate the diversity of styles. I used the Swedish lettering book (shown left) to write the title *Folk Art*. I also made a piece using templates from the lettering book. *Folk Art* is a collage using previously existing backgrounds oversewn with the lettering and then assembled patchwork style into one piece.

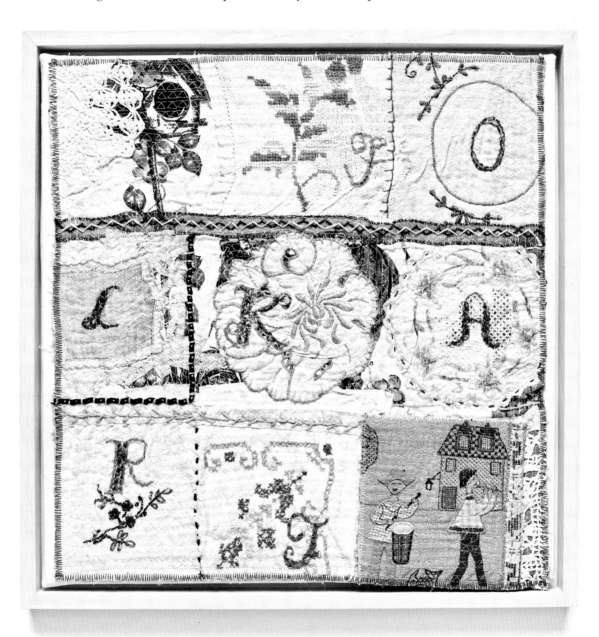

I found a table napkin with some lettering at a brocante fair in France and decided to use it as a background. To this vintage fabric I applied a series of small doilies in different colours. I drew on the lettering and stitched the letters by hand. Other details, like ribbons and scraps of vintage embroidery, were added later on. The colours for stitching were chosen based on the colours on the fabric background. Then the piece was mounted onto a backing fabric and framed.

Folk Art, mixed-media collage on textile. Notice how the arrangement of letters – not obviously divided into words – draws the reader in to look closer.

17

Hannah Lamb

I was interested to see how other contemporary textile artists use lettering in their work. Hannah Lamb is a Yorkshire-based textile artist and tutor at Bradford School of Art. She says:

'In 2015 I was invited to create work in response to a historic textile mill called Sunny Bank Mill near Leeds, West Yorkshire, for an exhibition titled *Material Evidence*. During my visits to the mill I drew inspiration from the buildings and the extensive company archives, noticing the grid structures seen in the mill and, on a much smaller scale, in the fabric samples in the mill's archive. All designs are numbered and recorded in the company archive, and could be adopted as a potential design colourway.

'Having a long-running interest in lettering, I was drawn to the labelling of the samples, either handwritten or printed on paper labels, or in some cases embroidered directly onto the cloth. I started to experiment with improvised patchwork and hand-stitched text, incorporating pieces of point paper (gridded paper used in weave design) and fabrics woven at the mill. I see sampling and improvisation as important processes in textiles both historically and in my own work. The works developed for *Material Evidence* are characterized by an experimental, sampling approach, with the pieces constantly evolving and changing shape. Some pieces that started out as straightforward fabric patchworks were then embroidered with lettering, cut up again and re-pieced, finally being inked up and going through the printing press to create fragmented responses reminiscent of the samples in the archive. The printed marks highlight the textures of cloth and stitches.'

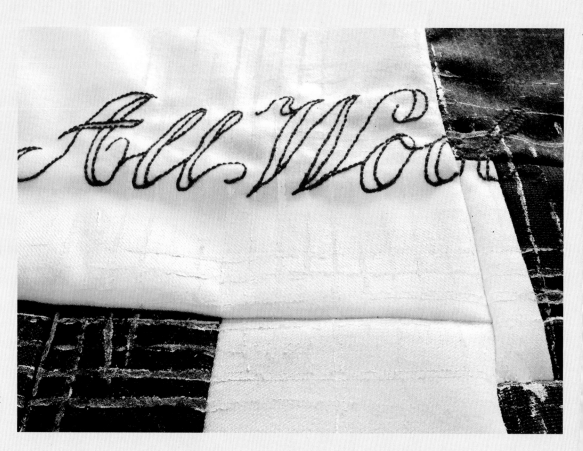

All Wool by Hannah Lamb. Wool patchwork with print and hand embroidery.

Jessie Chorley

Jessie Chorley is a London-based artist and tutor, with a shop in Hackney, London. She uses 'found' paper and fabric as her starting points for embroidery and drawing. Her work using vintage remnants is characterful and endearing. She runs classes from her workshop and encourages innovative ways of using old and new. Jessie uses her needle and thread to illustrate lettering and emphasize shapes and drawings.

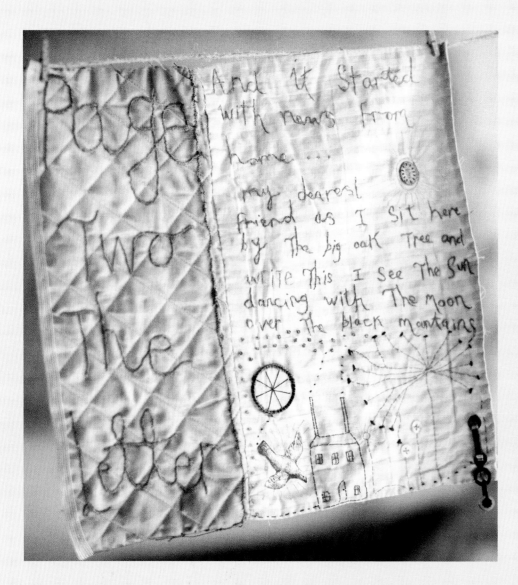

Above: Detail from
Page Two The Letter,
mixed-media textile by
Jessie Chorley.

Right: Mixed media
with quilt remnants,
embroidery and buttons.
Work in progress by
Jessie Chorley.

Recently Jessie has started the friendship quilt project, enabling her to connect with her followers by designing a kit that they can use in a coverlet. Jessie says, 'The project is inspired by the work I do as a travelling stitcher and as a tutor. I have designed this kit to celebrate the many lasting friendships that have been created through my workshops.' Using pre-worn and loved scraps of fabric is a huge part of Jessie's practice and she encourages her students to follow the same techniques. Her work has an inviting and friendly feeling about it and she displays it at her beguiling shop in London's East End.

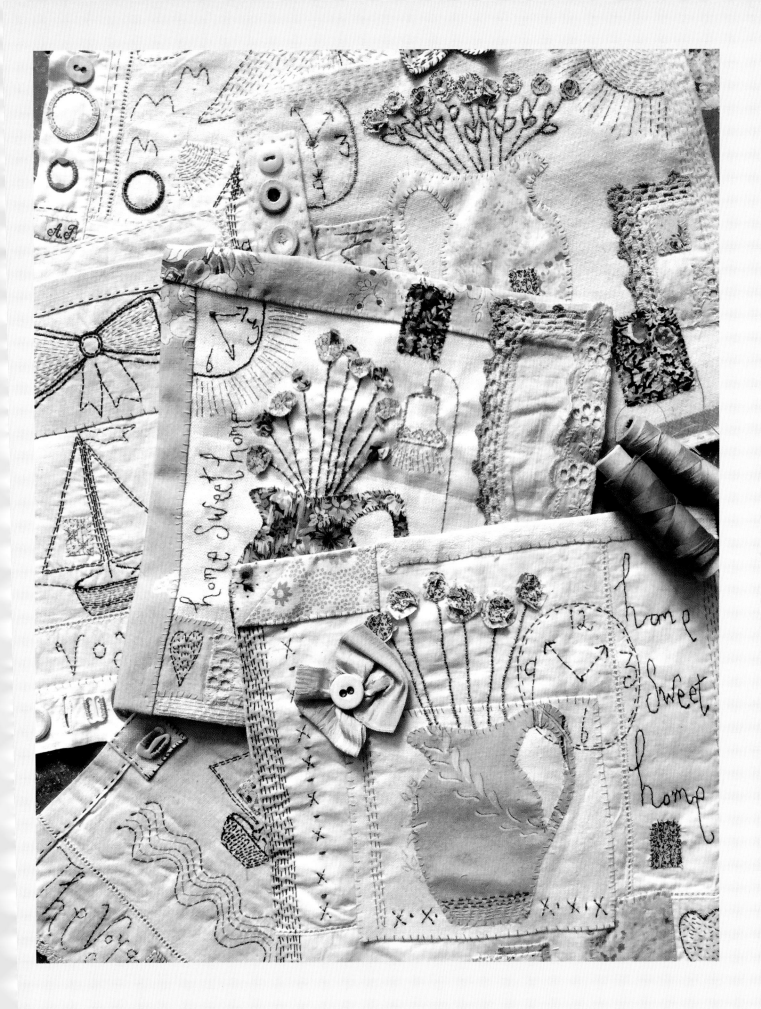

Repositories and Reliquary

Churches are becoming multi-use premises in many countries in a bid to re-purpose the buildings and to attract visitors and followers. They can also be repositories of religious and secular folk-style art. I exhibited at All Hallows' near the Tower of London, Tower Bridge, with painter Anna Dickerson. Our exhibition was inside the church, which is a very interesting building and the oldest church in the City of London. There are old models of boats hanging from the ceiling along the aisle that we exhibited in, and I added them to my piece *All Hallows* (shown right) using hand stitching. *All Hallows* is a large folding piece and shows many old buildings that would have existed during the long history of the church. The colours are muted and reflect the old stonework that surrounds the building and that part of London.

Above: *Two by Two* on exhibition at All Hallows', a church near the Tower of London.

Right: *All Hallows*, mixed-media textile on denim with appliqué and crewel work.

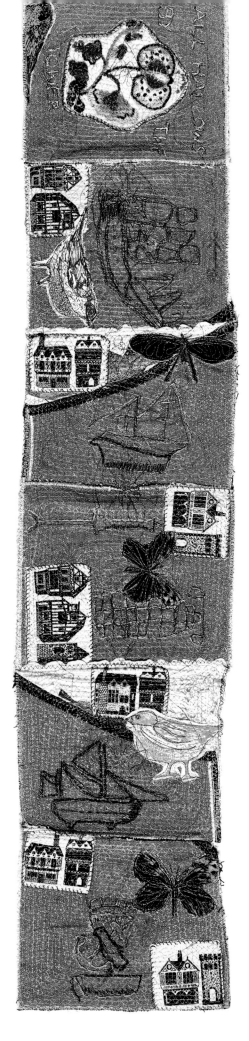

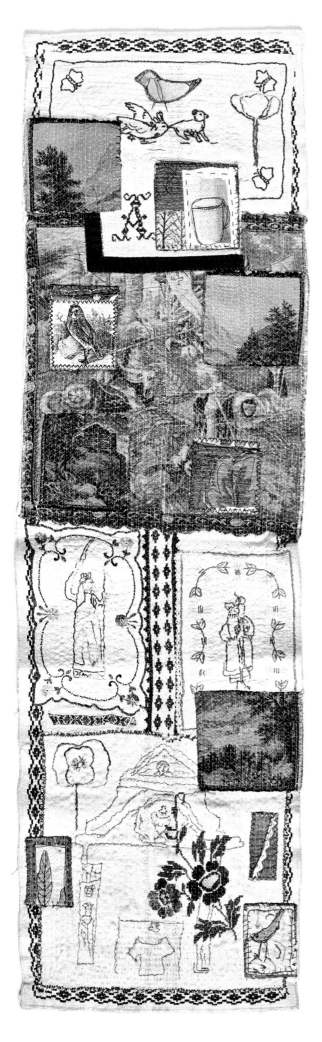

I was delighted to exhibit my work as part of the Les Aiguilles en Luberon textile festival in the south of France. Work was shown in around 50 venues in eight villages in the historic region, and my work was displayed in the village church of Peypin d'Aigues. It was a challenge to hang the work around the existing works of art in the building but fortunately the character of the church complemented the texture of the pieces there. *Peypin d'Aigues* (shown left), made in response to the exhibition, used fabric scraps found in the market in a nearby village. I started with a long tray cloth to which I tacked pieces of embroidery and fabric, using some original drawings of the church building at the bottom of the work. The piece was then overstitched.

Treasured Objects and Haberdashery

Christine Kelly (no relation!) is a UK-based artist and tutor – she works under the name Gentlework and it does feel exactly that way: peaceful and nostalgic words and phrases are combined with vintage textiles. She collects fabric and haberdashery and is inspired by the subtle variations of colour found in old fabrics and lace. She also uses old objects that she covers with textile and adds writing that contributes depth and meaning to her work. She says, 'I can get very attached to little scraps of fabric …'

Christine uses simple words and groups of words to covey meaning in her work. These allude to more complex emotions and memories. She often fits her work into tiny tins or around household objects and boxes. This makes the work feel even more special and precious.

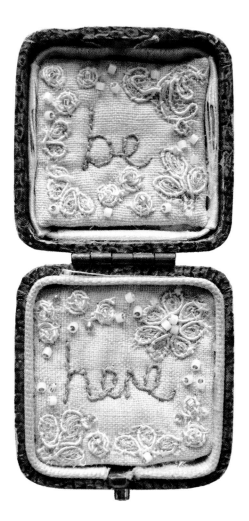

Above: *Be Here*, embroidered textile in tin box by Christine Kelly.

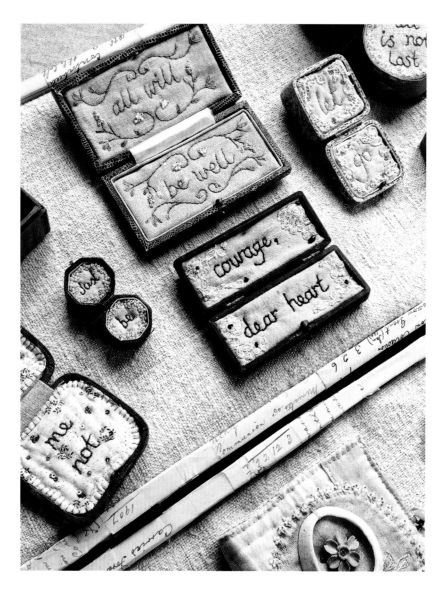

Left: Assorted mixed-media pieces with tin, wood and textile by Christine Kelly.

24

Sewing Box

As we can see, small everyday objects can become imbued with meaning when covered in stitch, and haberdashery shops are experiencing something of a revival, with makers clamouring to use vintage buttons, ribbon and any kind of packaging or cards relating to stitching and sewing. Where better to keep them, than in a vintage sewing box? I found this at a car-boot sale and have re-covered it, inside and out, using some free-motion embroidered pieces taken from my sketchbook.

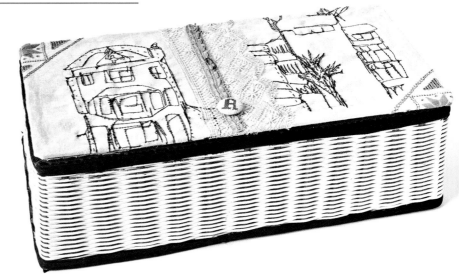

Left and above:
Interior and cover
of *Sewing Box*,
mixed-media textile
on vintage box.

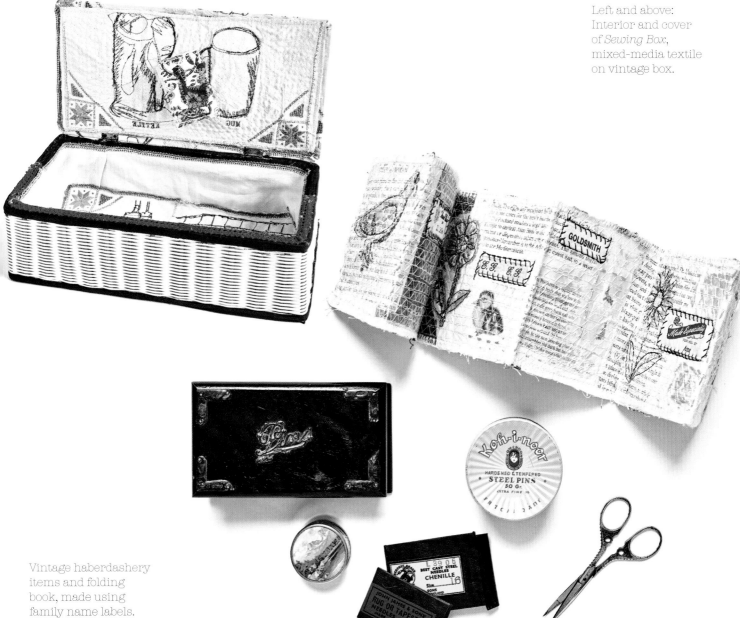

Vintage haberdashery
items and folding
book, made using
family name labels.

Pincushions

Another everyday object that can be classified as 'folk art' or 'everyday art' is the humble pincushion. Pincushions serve a useful purpose but they can take on a special meaning when personalized or decorated with a folk or other handmade motif. I have been gifted these, some as a child, and so each one has a unique importance and resonance.

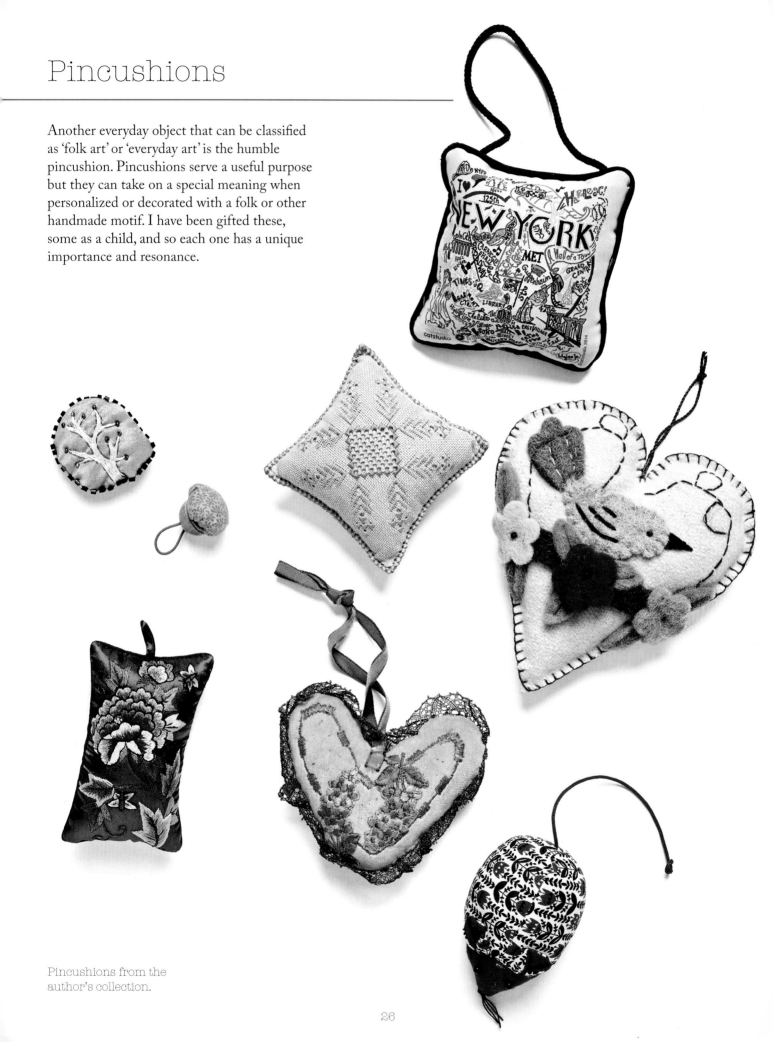

Pincushions from the author's collection.

Ruth Singer

Ruth Singer's project *Memorial Pincushions* uses the colour, style and character of the pincushions to build up a picture of a much-loved and complex person. She says:

'My aunt, Ann Goodstein, loved textiles. She inspired my love of cloth and of beautiful things. She died far too young when I was 17. This series of pincushions celebrates her vibrancy, her love of history and of things with stories to tell. Forty-six pincushions represent the 46 years of her short life and celebrate the joy she brought to many. I have a long-standing love of antique pincushions and studied them in museums including in the Gawthorpe Hall Textile Collection. I am fascinated by the incredible detail and wide variety of techniques found in pincushions and have tried to reflect this in my collection. I have worked with different materials, including 18th-century cloth, medieval pins rescued from the [River] Thames and found embroidery, and I have re-worked old pincushions, adding my own natural dye, patchwork and handmade felt. The colours and textures are those that I know my aunt would have loved, and I have included an old embroidery belonging to her. Using pins to create patterns and monograms is inspired by 18th-century pincushions given as childbirth gifts, and 'Forget me Not' pincushions from the First World War.'

Installation of *Memorial Pincushions*, a mixed-media and textile work by Ruth Singer.

Arks

I have chosen the simple form of an ark as it is closely associated with folk art and is symbolic of the often-biblical references seen on samplers. The arks are ornamental and are easy to create, using the same technique as for the covered travel box (see pages 14–15).

As well as the obvious Christian symbolism, arks can represent many things: sanctuary or home; the need for preservation and concerns about climate change; isolation and the idea of being adrift; family and inheritance, and new beginnings. It is a motif ripe for exploration.

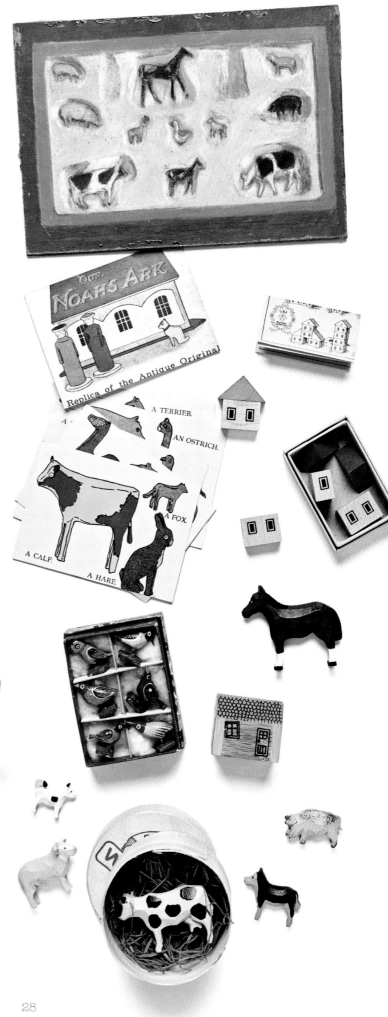

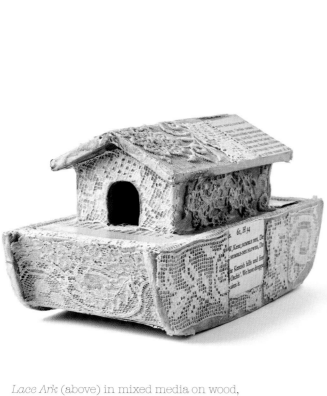

Lace Ark (above) in mixed media on wood, and the objects that inspired it (right), including *Anne Kelly's Ark Animals* in mixed media on hardboard.

Opposite: *Arks and Houses*, mixed media on wood, in situ at the *Folk Tales* exhibition at the National Needlework Archive in Newbury.

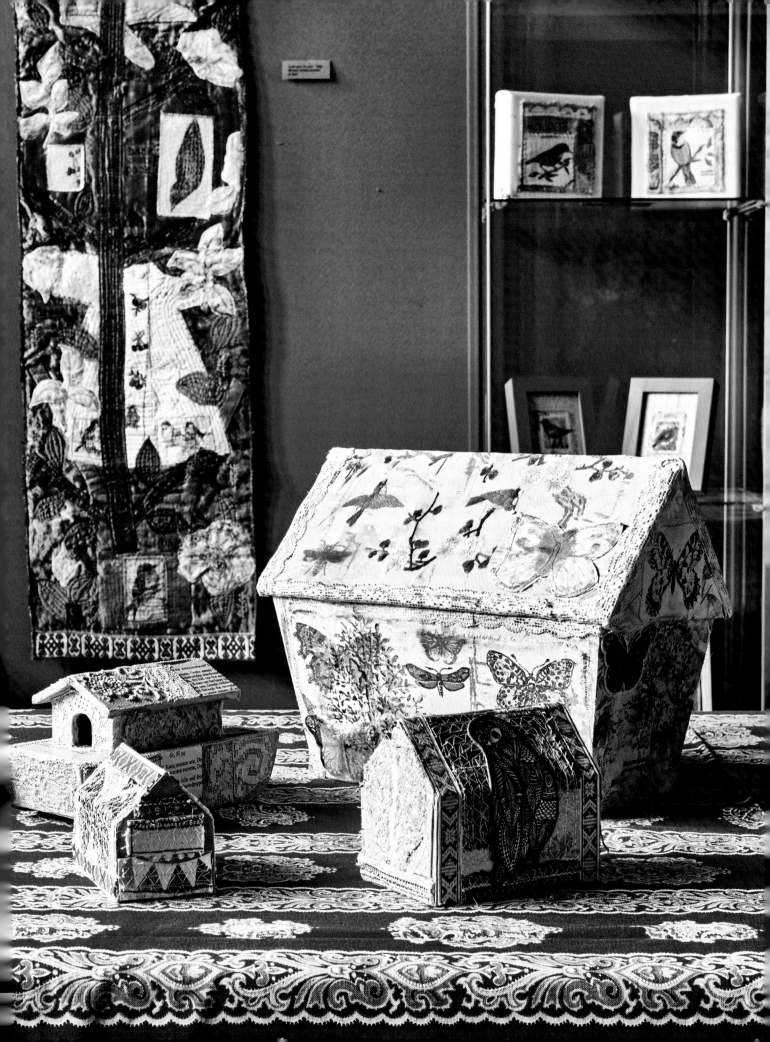

Nordic Notes

'The home does not have to be planned out in detail, just put together by pieces its inhabitants love.'

Josef Frank (Swedish Designer and Architect)

Detail from *Red Dress*, mixed media textile.

Nordic Motifs

In this chapter I will be looking at the Nordic influences on folk textile work, considering subject matter and materials, as well as inspiration and location. The countries that comprise Scandinavia share a rich and innovative history in the design and construction of folk-style textiles and craft. When examining images from Nordic designers of the last century, we can still find inspiration and appreciate the contemporary appearance of their work.

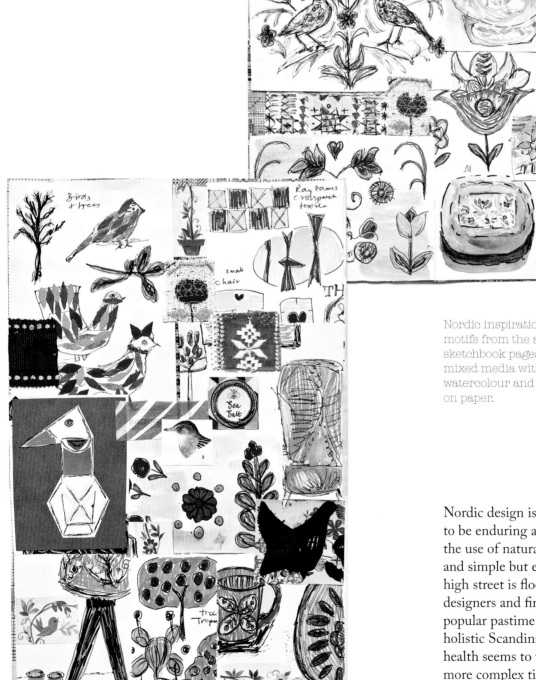

Nordic inspiration and motifs from the author's sketchbook pages, mixed media with pen, watercolour and collage on paper.

Nordic design is popular and has proved to be enduring as it encourages simplicity, the use of natural materials and colours, and simple but effective design. The British high street is flooded with Scandinavian designers and finding 'hygge' seems to be a popular pastime for many people today. The holistic Scandinavian view of life, work and health seems to work for many in these more complex times.

Nordiska Museet, Stockholm

I was lucky enough to be shown around the Nordiska Museet (Nordic Museum) in Stockholm, which has a wonderful collection of Swedish folk art. The embroidery department has rows of drawers with examples from the past 400 years. I found a simple embroidery of a man and a woman in traditional dress particularly inspiring and I decided to use it as one of the components of my *Folk Flag* piece (see pages 48–49).

My sketchbook drawings were either made at the museum or later from photographs taken during my time there. Making notes of the main lines, colours and shapes is necessary and effective for recording the work that inspires you. Most museums will let you take a pencil and sketchbook in while you are viewing exhibits, but it is a good idea to check first. Alternatively, drawing programmes exist for many tablets, and if you have a stylus you can take notes that way.

While in Stockholm I also visited the wonderful Almgrens Sidenväveri and Museum, an old jacquard weaving mill, which holds contemporary art exhibitions alongside its historical collection of silk weaving samples and a costume collection. It was wonderful to see traditional looms that are still working and in their original location.

Nordiska Museet
sketches, mixed media
with pen, watercolour
and collage on paper.

Dala Horses

Also in Stockholm, and whilst exploring the old town, I came across the Wooden Horse Museum, which is a collection of old and new carved wooden Dala horses. The Dala horse epitomizes Swedish folk art. Originally carved throughout Sweden, they are now primarily produced for the tourist trade in Dalarna, outside Stockholm. During the 19th century it became a custom to paint the wooden horses and richly decorative flower patterns onto furniture and walls. The carved wooden horses became part of the travellers' selection of goods for sale and spread throughout the country. I also saw some lovely felted and appliquéd embroidery, which has been a traditional method of decorating and embellishing fabric since the 19th century.

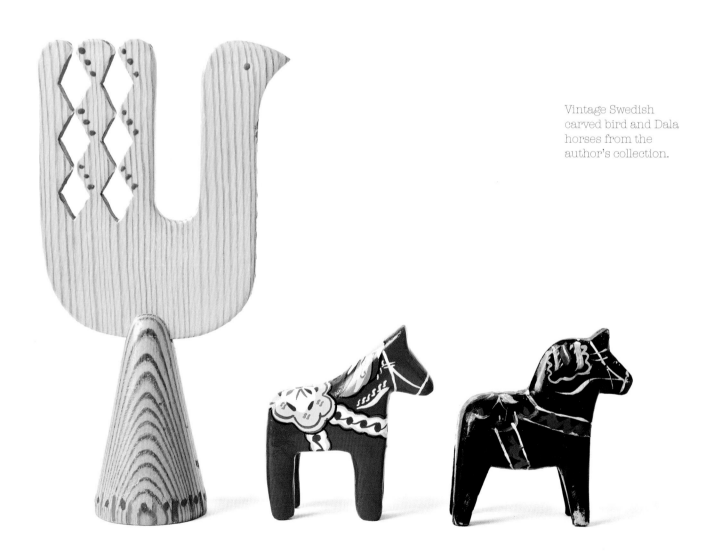

Vintage Swedish carved bird and Dala horses from the author's collection.

Asa Westman

Katarina Thurell was my guide in Stockholm. She makes beautiful small embroideries using vintage elements and found embroideries. She uses pieces from charity shops and combines them with hand and machine stitching, as can be seen in her bird badge shown on page 83.

Katarina suggested that I look at the work of Asa Westman, who makes beautiful embroidered clogs. She uses traditional Swedish embroidery techniques, often starting with a felt base. She adds shaped appliquéd pieces, such as flowers, hearts and Dala horses. These pieces are completed with an array of embroidery stitches, like fly, French knots and blanket stitch, and finally with sequins and buttons. The panels that Ava places over the front of the clogs are sewn on with the addition of ribbon to cover the edges. Ava says:

'I grew up in the big city. At the age of 33, I moved to a smaller town and six years ago to a very small town with around 300 inhabitants in northern Dalarna. I enjoy and am influenced by all the culture in Dalarna. My motifs for embroidery most often are flowers, Dala horses and hearts – much borrowed from costumes and paintings. The embroidery is colourful and contrast-rich.

'The material I use is always worn or old, and threads are in linen, wool and cotton. On larger embroideries I use text, and the embroidery often has a meaning. In the village of Oxberg, not far from here, there is a wooden shovel factory. A nice visit there ended when I found templates for my clogs to take home. I embroider and decorate the clogs, always with different applications on the right and left, but in the same colour themes. Then, the shoes are fitted and get their finely shaped toe.'

Embroidered Clogs by Asa Westman, embroidery on felt attached to wooden clogs.

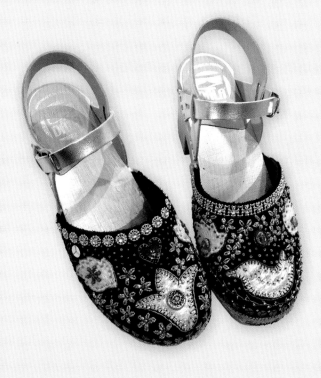

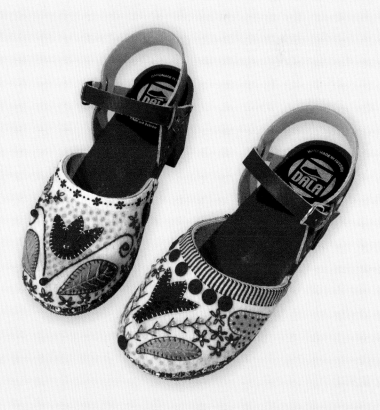

Nordic Inspiration

Nordic design is inspirational and here I have chosen some objects that have influenced my work. The Dala horses were purchased in Germany and Sweden, both made in Dalarna. The vintage wooden bird is from Stockholm, and the long card is a design by Sanna Annukka – a Brighton-based Finnish designer – for Nordstrom department store in Canada. The small framed embroidery sample is another charity-shop find, made in Denmark. The samples of Nordic embroidery are courtesy of Tanya at Linladan Embroidery – she sells threads for embroidery and also has a great collection of vintage pieces.

You can't beat travelling to a country or region to find inspiration, but these days you can make 'virtual' visits online and find plenty to spark your ideas in exhibitions, books and catalogues.

Nordic inspiration (from top to bottom): objects from Scandinavian countries, including cards from the Nordiska Museet in Stockholm, vintage bird, long card by Sanna Annukka for Nordstrom, Josef Frank exhibition flyer from the Fashion and Textile Museum in London, and threads and folded tablecloth from Linladan.

Small Folk Collages

I like to work in series and on more than one piece at a time, and I wanted to make some small pieces that would reference Nordic and folk imagery.

First, I isolated some images from my collections of Nordic work. I then simplified them with a thick pen to indicate which pieces should be cut out. Next I added pieces of fabric and ribbon to six small (A6 size) pieces of strong fabric. I used some Japanese tissue paper to tone down the backgrounds. All the pieces were attached with a thin layer of glue from a glue stick. I varied the colours to make the pieces more interesting, and included ribbon scraps in each one. Then I overstitched each piece with an edging stitch. The pieces were finished with hand stitching in stranded cotton.

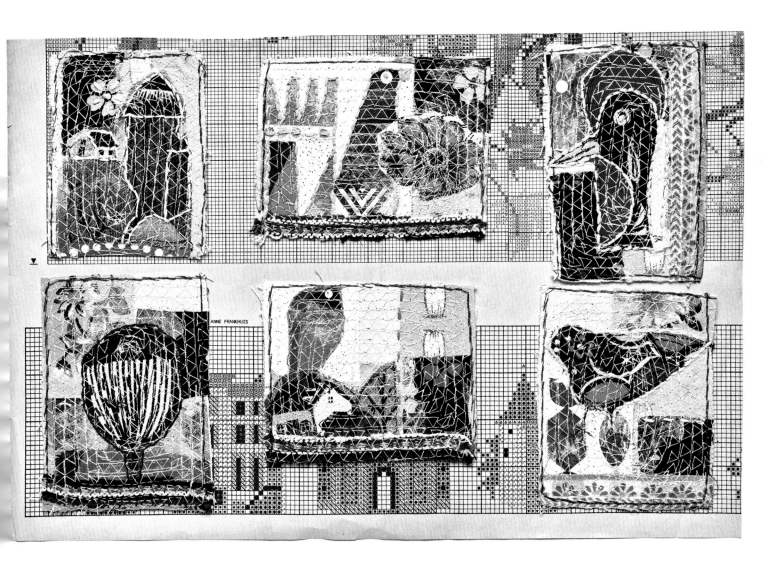

Small Folk Collages,
mixed-media collages,
fabric and paper on cloth.

Wooden Houses

When I was staying in Stockholm I was inspired by the wooden architectural shapes I saw everywhere. I found two balsa-wood models of houses in an art-supply shop and decided to cover them, in a similar way to the travel box on pages 14–15. I started with a patterned paper base, and then added embroidered fragments and ribbon, as well as fabric scraps.

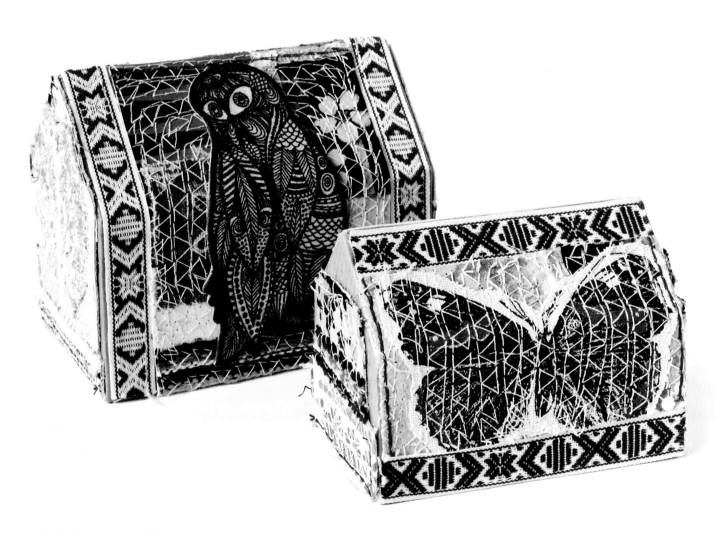

Wooden Houses, mixed media on balsa-wood base (see also page 29).

Gillian Travis

Gillian Travis is a UK textile artist and tutor. Her travels take her all over the world and her work reflects this. She says:

'I love to travel and have found so much inspiration for making my contemporary quilts from visiting ethnographic museums all over the world. I research the patterns and designs found on traditional costume and artefacts, admiring the work carried out. Bags, skirts and shoes were hand stitched, and jumpers, hats and mittens hand knitted.

'The quilts I make are often small, and are always machine stitched. By using my domestic sewing machine and natural fabrics (such as wool felt and a wool/acrylic thread), I can replicate the appearance of hand stitching as seen on the red quilt *Sweden* (below). I screen print the backgrounds of my quilts with patterns found either on cross-stitched clothing or knitted jumpers and mittens, for example on my series of jumper and mitten quilts. I made a series of these quilts – it was so much fun using many of the little-used automatic sewing machine patterns.'

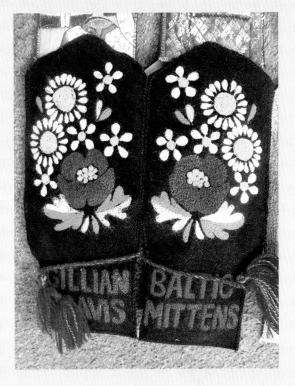

Above Right: *Baltic Mittens* (detail) by Gillian Travis, wool embroidery on felt.

Right: *Sweden*, by Gillian Travis, mixed-media textile embroidery on felt.

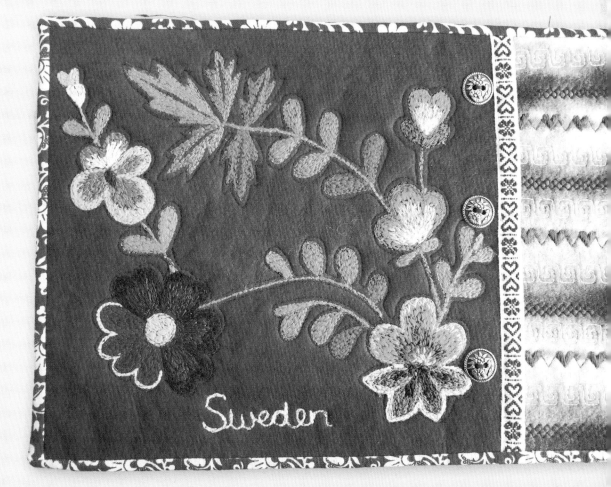

39

Mandy Pattullo

Mandy Pattullo is a well-known UK textile artist and tutor. Her work, whether appliqué or wool stitching, tries to capture the simplicity of design often found in Nordic and traditional North American textiles. She says:

'I respect the history of patchwork and quilt making and the way women have always used scraps to create beautiful and functional pieces. I too try to use materials that I already have in my work or utilize things that have been gifted to me. I nearly always use part of an old quilt as the foundation for my work and like to handle fabrics like this which have a history and which relate to the thrift and 'make do and mend' culture of past settings. I am particularly fond of Baltimore and appliquéd quilts made by early settler families in the United States. The time-consuming appliqué often told the story of the importance of certain things in their lives, such as livestock, homes, gardens and relationships. I have made extensive drawings from my research into old appliquéd quilts and from folk art from other cultures too, and have then created my own appliqués but have taken them a little further than the tradition by also embellishing with hand embroidery.'

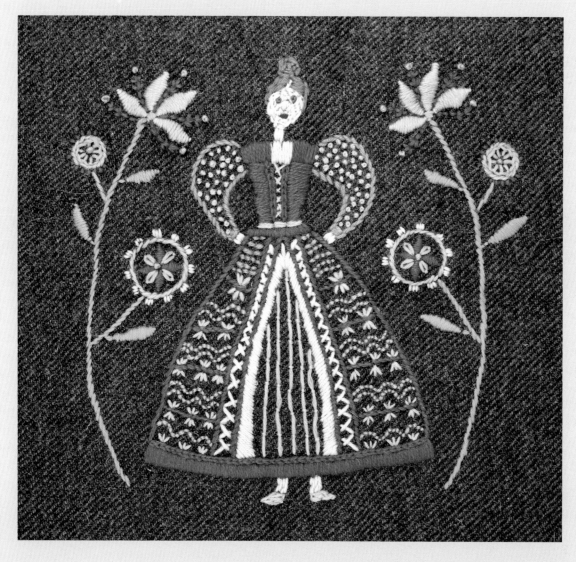

Folk Lady Full by Mandy Pattullo, mixed-media textile in wool work.

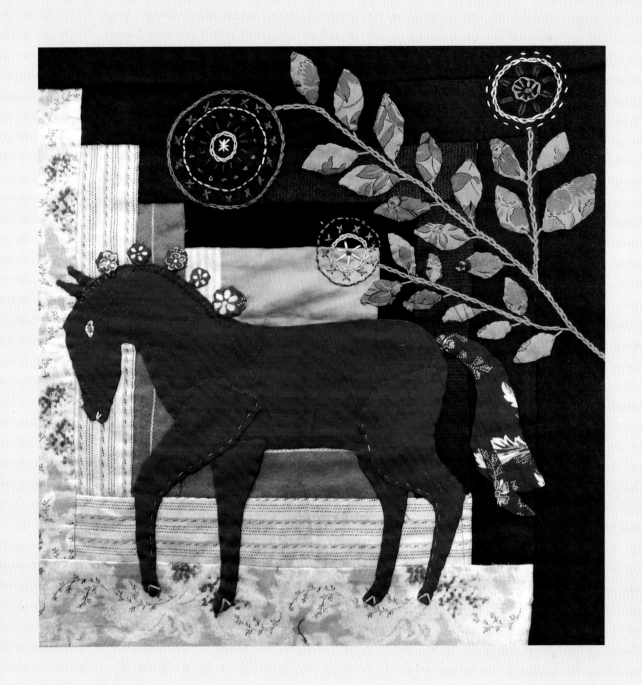

The Red Horse by
Mandy Pattullo,
mixed-media
textile, appliqué and
embroidery on vintage
quilt background.

Svenskt Tenn and Josef Frank

The themes of nature and richly developed pattern are also striking in these designs. Nordic designers maintain a clean and uncomplicated approach to their work and you can see this when looking at the drawings of Josef Frank (1885–1967), a Swedish designer (born in Austria) whose amazing drawings of plants and flowers are still in production today. They are used by interior designers throughout the world and maintain their freshness.

Left: *Mirakel*, designed by Josef Frank and produced by Svenskt Tenn. Frank was inspired, in part, by the work of William Morris and the Arts & Crafts Movement in the UK, and you can see some of that influence here.

Right: *Red Tree* and Svenskt Ten *Mirakel* printed textile on cushions in the author's home.

Josef Frank, who was the subject of an exhibition at the Fashion and Textile Museum in London in 2017, lived and worked in Sweden in the early part of the 20th century. His work is based on natural forms and organic shapes, but simplified with colours that are bright and almost luminescent. His work continues to be manufactured by the Swedish design house Svenskt Tenn. I particularly like his design *Mirakel*, which I have used with some furniture at home.

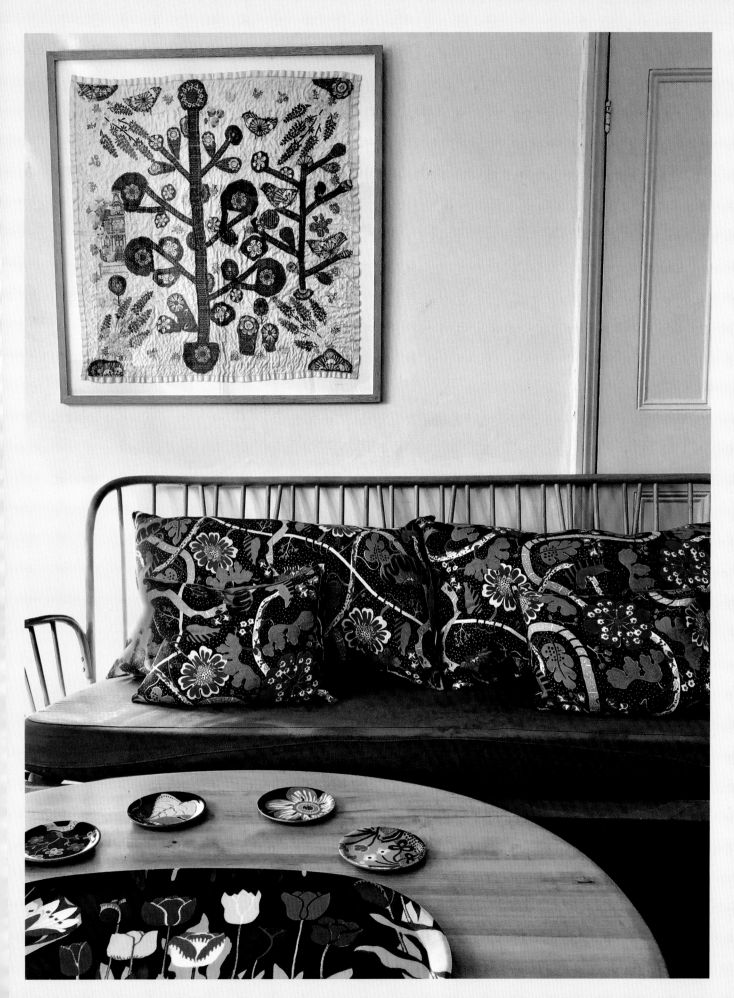

Red Bird Home Apron
and *Red Tree*

While visiting family abroad, I like to work if I have space and time, unencumbered from the everyday tasks of running a studio and home. On a recent American trip I worked on two pieces. I found a wonderful apron in a charity shop and immediately knew that I wanted to use it for a piece of work. I used stencils of trees to decorate the background, which was made of pale coloured linen. I then applied the apron with appliquéd images of birds over the top. The whole piece was overstitched and became *Red Bird Home Apron*.

Red Bird Home Apron, mixed-media textile with vintage fabric and stencilling.

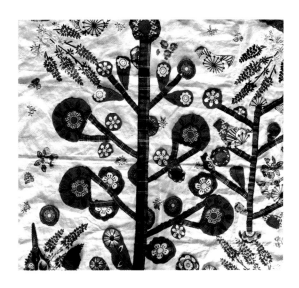

Red Tree was started on a visit abroad, using remnants of fabric and a backing cloth found on my travels. I used a large tree motif as the central image and selected smaller pieces of embroidery as leaves. I wanted to make the most of the embroidered tablecloth background so I left much of it uncovered. The tartan ribbon trunk for both the larger and smaller trees was lightly glued and tacked down. The secondary branches were added in the same way. I cut out the circular motifs from another piece of vintage fabric found at a charity shop. Leaf and bird shapes were included in much the same way. There is a needlepoint image of a house on the left of the piece that was incorporated towards the end of the composition to add balance. After the images were firmly tacked by hand, the piece was overstitched using my signature Bernina stitch. Red Tree was then backed, ready for framing.

Red Tree in progress (above) and completed (below) with vintage fabric, ribbon and needlepoint.

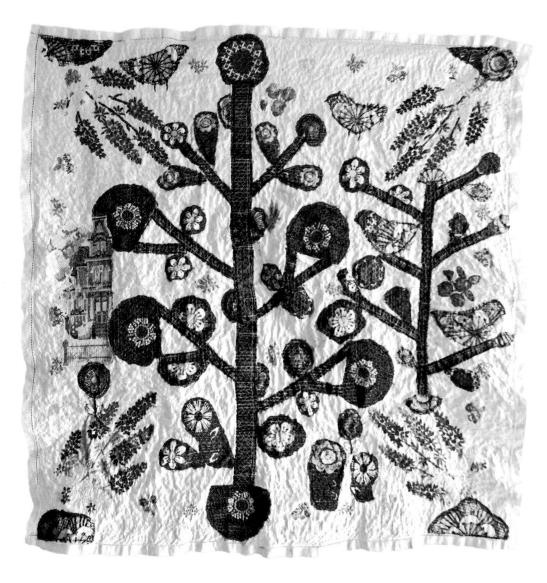

Bird Screen Print and Collage

When I was selected to exhibit in a gallery at the Knitting and Stitching Show in London, I wanted to make some small pieces that were easy to produce and transport. I decided to make a series of folk collages, using simple animal and tree-of-life motifs. I used a straightforward stencil screen-printing technique to create the prints on old book pages and then appliquéd the collage over the top when dry. The pieces were then covered with organza.

Work in progress: screen prints drying in the studio.

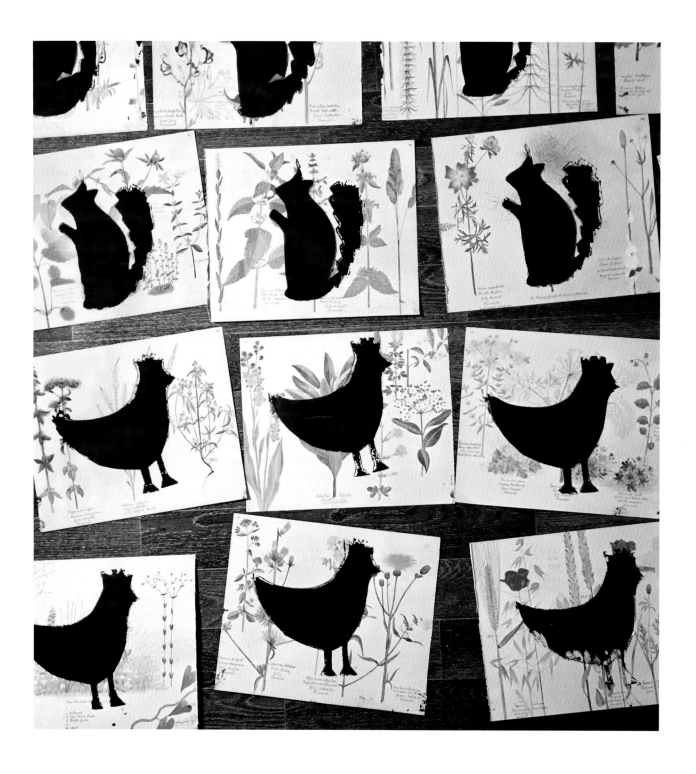

Making a Screen Print

MATERIALS AND EQUIPMENT

» Pencil

» A4 or A3 cartridge or sugar paper
(depending on screen size)

» Scalpel

» Masking tape

» Screen

» Screen-printing ink (or fabric paint
mixed with screen-printing medium)

» Brush

» Squeegee

» Natural fabrics (non-stretchy)

» Thread

Bird Collage, mixed
media on card (left) and
Bird Appliqué, mixed
media on organza (right).

1 Choose a simple silhouette motif.

2 Draw it onto thin cartridge or sugar paper with a pencil and
cut out using a scalpel, leaving a border around the edge.

3 Tape your stencil to the outside of the screen.

4 Using a brush or the edge of your squeegee, apply a thin but even
coat of ink to the inside of the screen.

5 Pull the squeegee across the surface of the screen. It is a good idea
to make a test print on scrap paper to ensure the screen is coated
before using 'good' paper.

6 When you have finished printing, wash everything thoroughly
so the mesh of the screen does not become blocked.

7 When your prints are dry, appliqué parts of the design with small
pieces of fabric, leaving the outline of the print to show, and then
stitch around tshe shapes. For this piece, I added a layer of clear
organza to finish it, and then stitched around the edge on the
sewing machine.

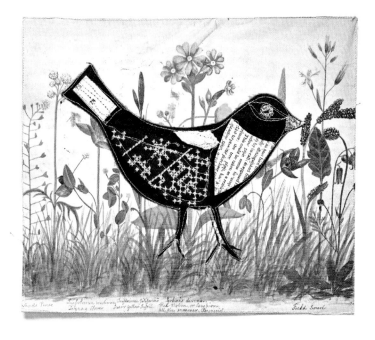
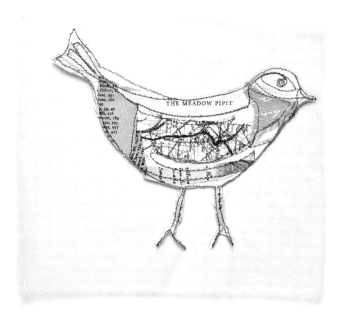

Folk Flag

Fabric scraps and samples with a common theme can be put together as a long banner or flag. This piece started with a drawing at the Nordiska Museet in Stockholm, and all the elements have a folksy feel.

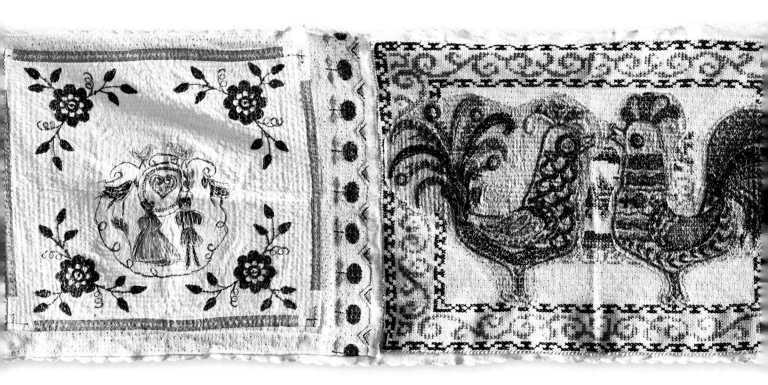

Folk Flag, mixed-media collage with vintage elements.

I had made a drawing of an embroidery featuring a couple in traditional clothing while at the Nordiska Museet and knew that I wanted to make something from it. I made a simple interpretative copy of the drawing of the couple on drawing paper, and then traced it onto the back of a vintage textile. I put a black thread in the bobbin of my sewing machine, with a dark thread on top and used the free-motion foot to 'draw' around the outline of the man and woman. I then filled in the images with some coloured stitching. This piece of vintage textile was then placed inside another with a hole in the middle – it had been used for decoration around a candle. The piece was then inserted into a border and joined to the other pieces of work forming the finished *Folk Flag*.

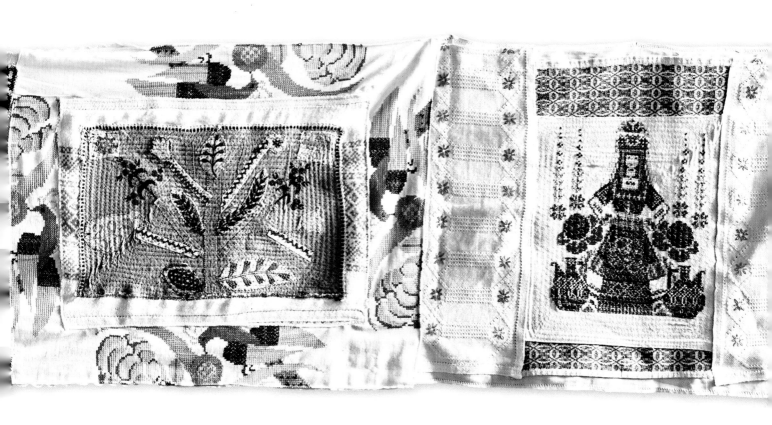

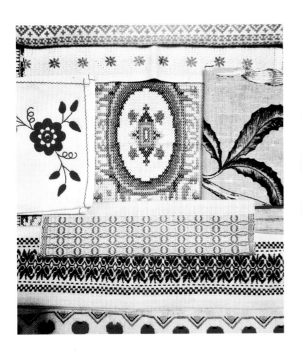

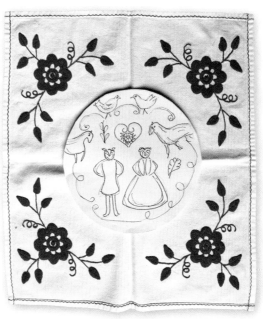

Nordic fabric (far left) and work in progress (left) used in *Folk Flag*.

The Silk Road –
Travel and Memory

*'A thousand-li journey is started
by taking the first step'.*

Chinese Proverb

Hand-stitched Mongolian
embroidery from a yurt.

Mongolian Memories

Imagine yourself in a soft, felt-covered dwelling in the late afternoon on a warm summer's day, surrounded by sweet-smelling grasses and a beautiful landscape. This is where I found myself a few years ago, in Inner Mongolia, in a yurt. I was fortunate to see some embroidered examples of work from generations past, alongside stencilled and hand-painted furniture. The yurt was developed for nomadic people to travel around the prairie, steppe or plains, while following their livestock. In recent times yurts have become a comfortable way to camp for some people in the West, but they are still used in other parts of the world as a home.

Jewellery made by a Mongolian craftswoman from animal fur, beads and leather.

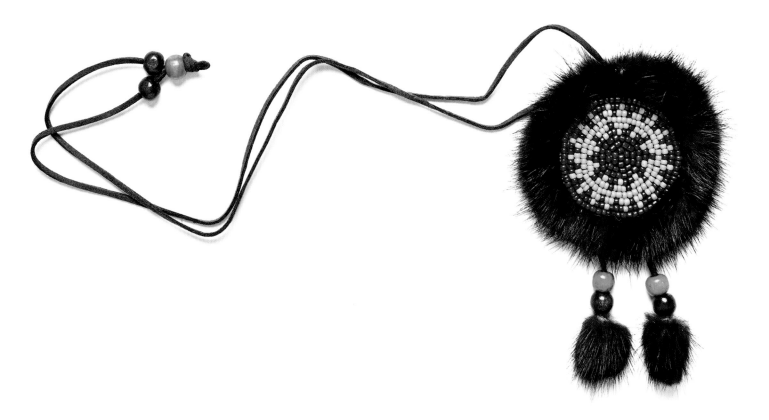

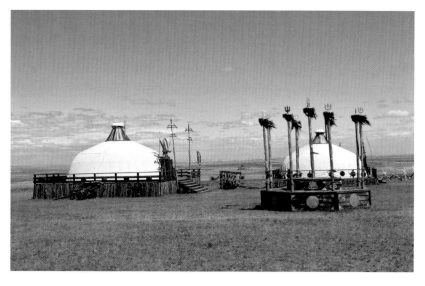

The embroidery that developed in these yurts is distinctive. It uses patterns that link to older oriental motifs and yet are individual and original. The clothing and footwear of the yurt dwellers is also decorated with embroidery and pattern. I visited a workshop where present-day craftswomen make tradition-inspired jewellery, garments and souvenirs for tourists. They use a mixture of beading, stitch and hides gathered from hunting expeditions. Many of the motifs on their work bear an uncanny resemblance to Northern Canadian and American native work.

Mongolian Journey

I made a collage using my photographs from Inner Mongolia as a guide. I was given a piece of densely embroidered cloth while I was in China and used it to create the shapes of the landscape. I added garment shapes that I had seen at the Summer Palace in Beijing, as well as sketches of animals and birds completed on my travels. The whole piece is bound together using my edging stitch and was completed with some additional hand stitching and a little colour in the form of dye paints.

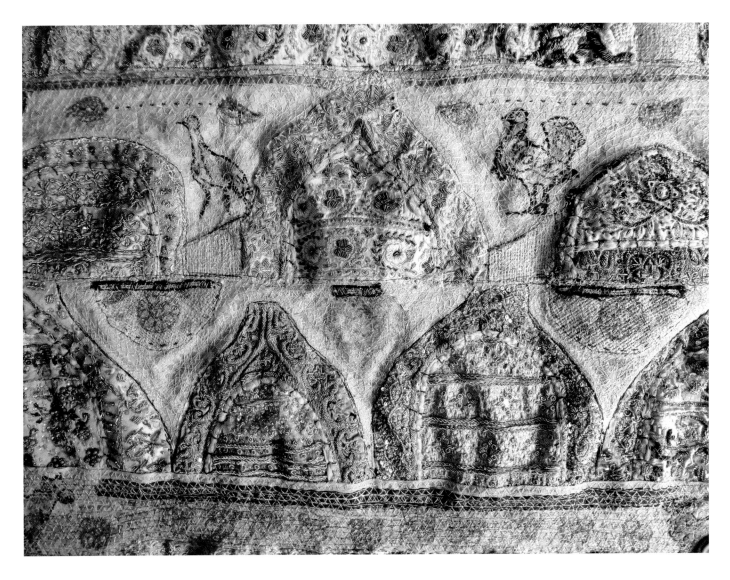

Mongolian Journey,
painted and printed
mixed-media textile with
added embroidered and
embellished fragments.

Beijing and Bugs

In Beijing street markets, it is still possible to find original examples of folk-inspired embroideries. These are brightly coloured and richly constructed. There are 51 nationalities in China and they each have their own unique history of pattern and stitch.

Chinese embroideries using silk thread on silk fabric, from the author's collection.

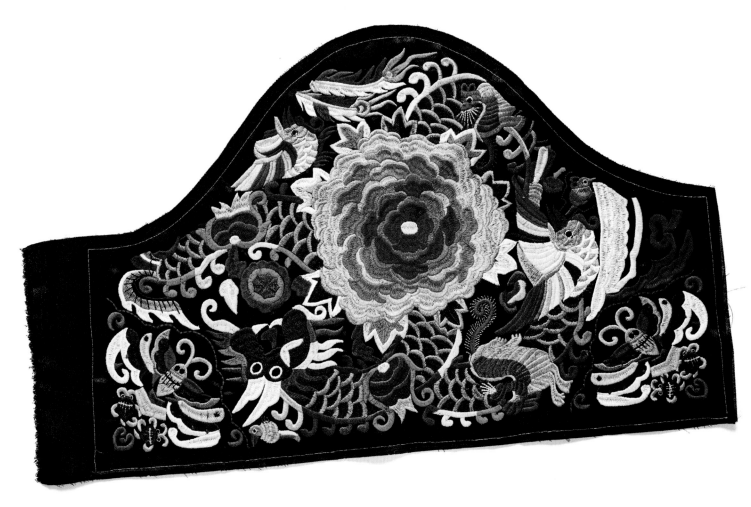

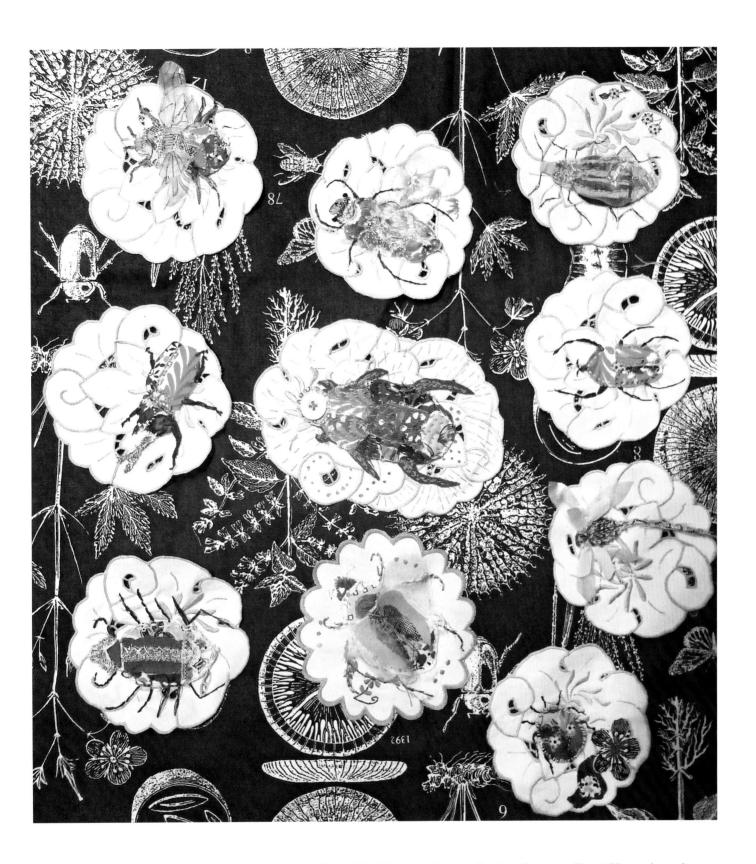

Embroidered beetles from a workshop hosted by the author in Beijing. Mixed-media textile collage with hand stitch.

After travelling through China, I held a workshop in Beijing. It was at Duzii Yinyue's studio, where she makes wonderful felt sculptures of animals and natural forms. We made bug 'postcards' using a simple template and developing individual designs with the fabric provided. We started by drawing the outline of the bug onto a background, and cutting out shapes for the body from the fabric we had chosen. We then tacked the body shapes onto the background before stitching and embellishing the rest of the beetle. The work looks Chinese while retaining its folk character.

Buglife Collaboration

I continued with the theme of insects by developing a community collaborative piece for the Knitting and Stitching Shows in London, Dublin and Harrogate in 2016. I wanted to continue working with a conservation charity, and decided to fundraise for Buglife by producing a book of my insect embroideries, and selling copies at the shows. I also invited collaborative pieces via social media and was delighted to receive a varied and truly international response. These examples – seen below – were exhibited at the shows and we raised a good sum of money for the charity.

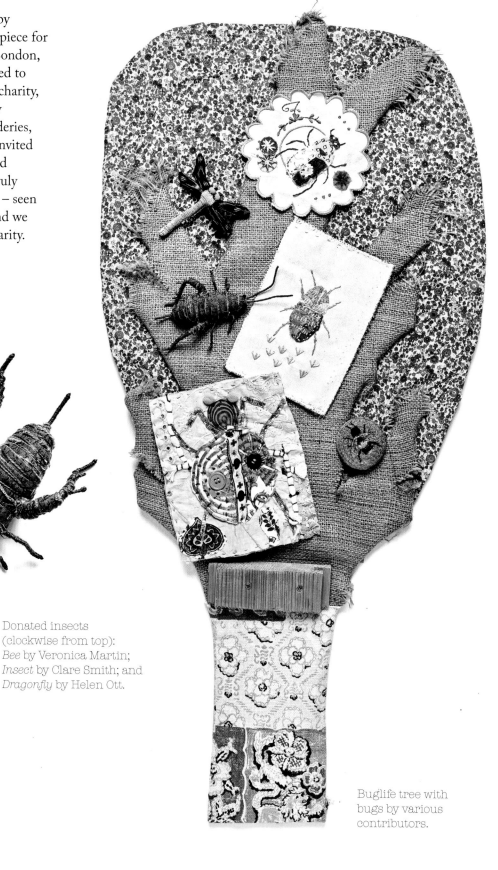

Donated insects (clockwise from top): *Bee* by Veronica Martin; *Insect* by Clare Smith; and *Dragonfly* by Helen Ott.

Buglife tree with bugs by various contributors.

Bella May Leonard

Bella May Leonard is a recent graduate and successful artist working on a large, sculptural scale and using folk patterns as inspiration. Her work draws on themes as diverse as baby bonnets and smocking patterns, and she has been an artist in residence at Gawthorpe Hall in Lancashire, run by Lancashire County Council and the National Trust. Bella uses a variety of materials including thread and wire in her work. She says:

> 'Hand embroidery is integral to my practice and I find it an unusual way to gain insight into other cultures. Where possible I research historic textiles and how they were made first hand, combining my own sculptural interpretation with contemporary materials. This directs me to learn more about ancient cultures but also domestic life across the world, as well as bringing more awareness of what "craft" means in the post-industrial West. The process of hand embroidery in its broadest sense appeals to me because of its labour-intensive qualities and elaborate possibilities.'

Bella May Leonard,
mixed-media sculpture.

Dijanne Cevaal

Dijanne Cevaal is a nomadic textile artist. Originally from Australia, she spends much of the year travelling. This is what she has to say about her *Travellers Blanket* series:

> 'They started life thinking about how you might record a journey or travels if you were to record without writing. I was thinking about some of the early travellers who might have accompanied Marco Polo or Ibn Battuta – how would you encapsulate memories of what you had encountered? And so the blankets started to grow from using scraps of fabric, which might have been morsels you gathered on travels, to little maps of embroidery to portray different feelings and discoveries. They started to take on a life of their own. It takes me a long time to make a blanket because they are very densely stitched and seem to have a way of determining just how they will emerge.'

In the detail shown here, you can see the stitching and collage working together.

Detail from *Memory Blanket*, mixed-media textile and embroidery by Dijanne Cevaal.

Glenys Mann

Glenys Mann makes work based on her experience and exhibits widely throughout Australia. I saw this piece when I was tutoring in Ballarat. It explores a message of safety and home. This is her statement:

'Waiting … Remaining in one place, stationary or quiescent, so as to be ready for some expected event.' (Oxford English Dictionary, Shorter Edition, 1933.)

'*Waiting #16 Bundled.* There is an aura of protective covering about cloth. Keeping 'them' safe from harm; swaddling; quilts from old memory blankets; stitching against intrusion; and so on… a beautiful image of a carefully and lovingly made shawl and baby clothing. Think of layettes (a word not used by today's young mothers), feather and fan stitch, crochet, clothes made by a mother's/grandmother's hand … It will awaken and stir hearts and memories. All bundled until the time is right.'

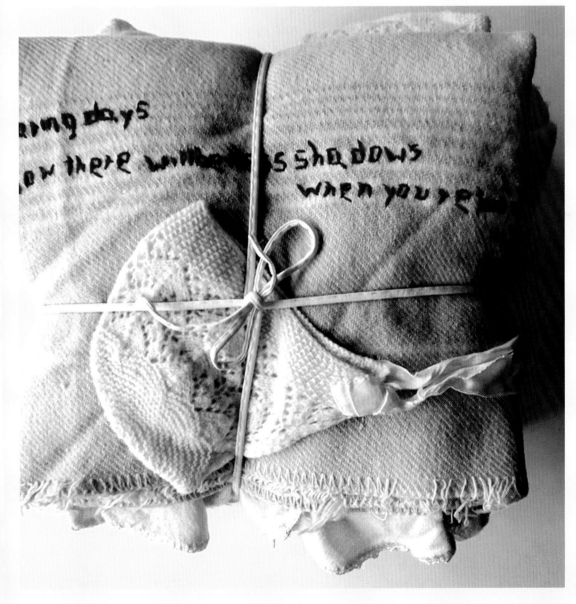

Top view of *Waiting #16 Bundled*, mixed-media and hand embroidery by Glenys Mann.

Travel Tags

The theme of travel will certainly conjure images of baggage, or luggage, and luggage labels. I wanted to create another collaborative project to accompany my exhibition at the London Knitting and Stitching Show so I asked contributors to make travel tags for my exhibition and made two covered suitcases to display them with. The project was called *Travel Tags – Moving Memories*.

Suitcases are evocative of many emotions and conjure up images of displaced people as well as those of the wealthier population going on business trips or holidays. I am conscious of the issues surrounding immigration, being an immigrant myself, and having a family history of immigration to the UK. I wanted to support the homelessness charity Shelter and made a small book to sell in aid of it. More of the tags are shown on page 128.

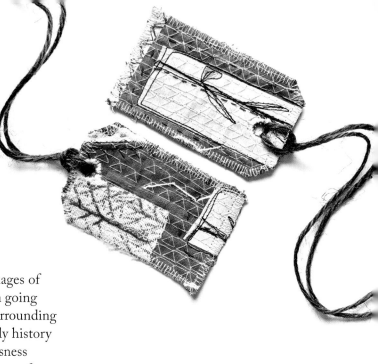

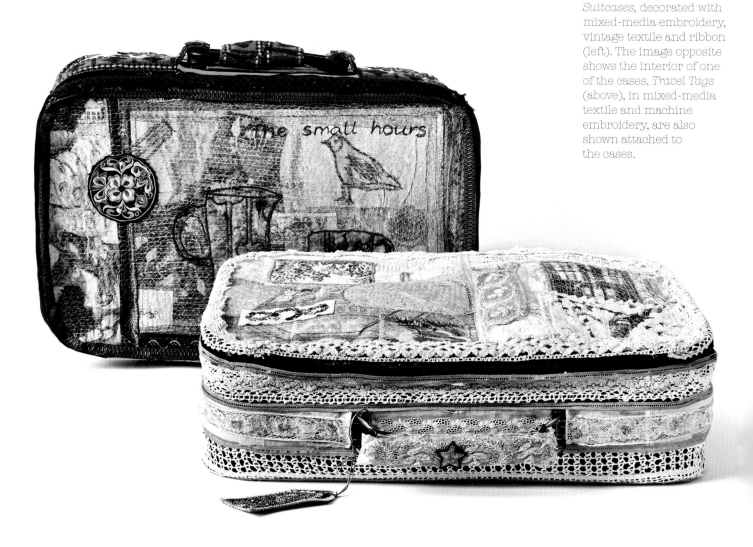

Suitcases, decorated with mixed-media embroidery, vintage textile and ribbon (left). The image opposite shows the interior of one of the cases. *Travel Tags* (above), in mixed-media textile and machine embroidery, are also shown attached to the cases.

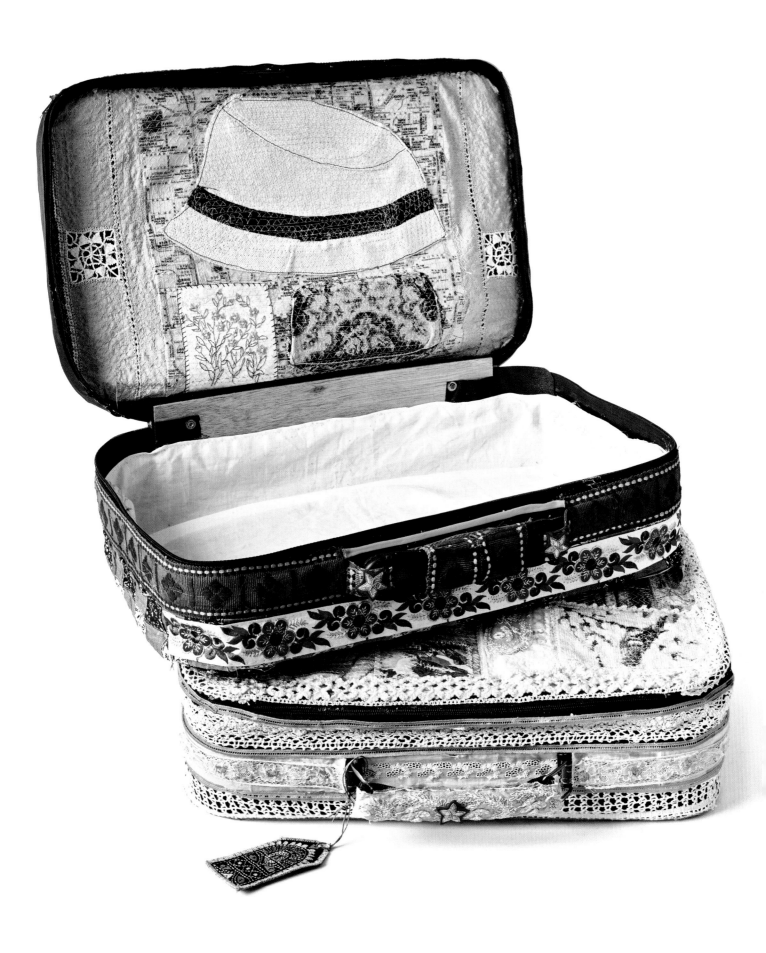

Indian Folk Art

Simple, traditional and colourful motifs are to be found all over India. Craft and the handmade is celebrated everywhere from the smallest villages to the largest cities, on everything from buildings to trucks and cars. The range of textile techniques, still produced to a very high level, is impressive. On a recent visit to West Bengal I was fortunate to see first hand the processes of making khadi cotton and silk as well as the subsequent decoration (printing, weaving and hand stitching) of it. We were taken to collectives where the final fair-trade product is sold to the government shops and the public.

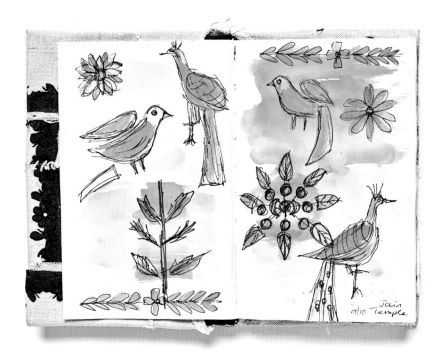

Above: Sketchbook page of pen-and-watercolour drawings made during a visit to India.

Left: Samples of hand-stitched and kantha textiles from West Bengal, India.

Among the motifs that were popular were small figures and elements of daily life, embroidered or printed onto silk and cotton. Plants and flowers were in abundance and their simplified shapes were interpreted in a variety of techniques. We attended two kantha workshops, where the design was transferred onto a loose-weave dyed cotton. The stitch is worked with a long needle, gathering cloth from the top layer of the fabric, several stitches at a time. The resulting effect picks up both the design and the light when executed in a contrasting colour.

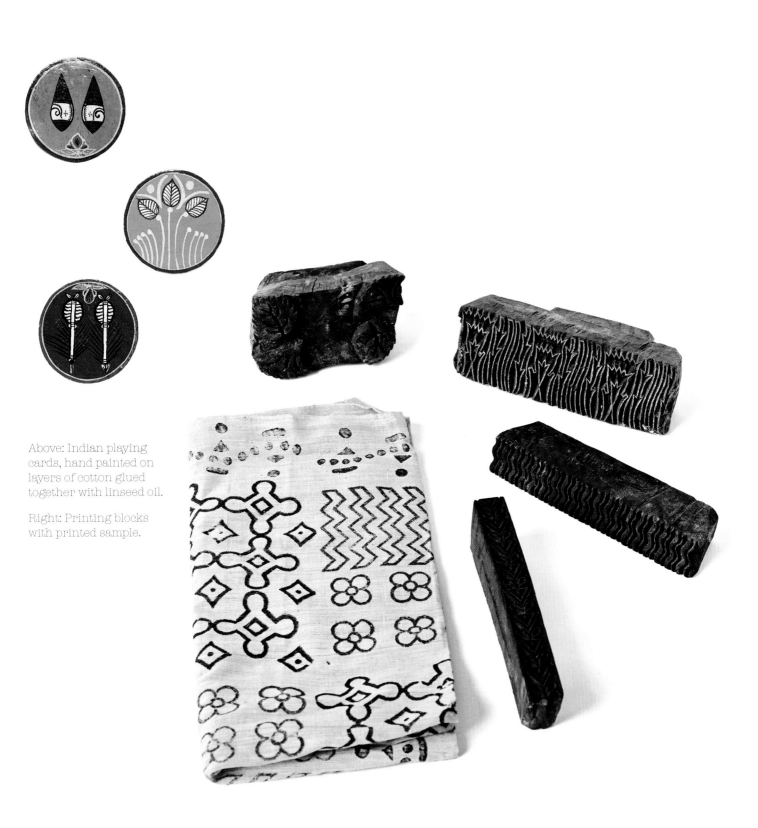

Above: Indian playing cards, hand painted on layers of cotton glued together with linseed oil.

Right: Printing blocks with printed sample.

We visited a workshop where the simply decorated but carefully manufactured playing cards shown above were made, using many layers of cotton pressed together with linseed oil. We also attended block-printing workshops, where the hand-carved wooden blocks were lightly dipped into a handmade ink pad made with a washable dye/ink combination. Above are some blocks from our workshops.

Folding Books –
Travels in Textiles

The aim of this project is to create a special folding piece based
on a favourite journey or place.

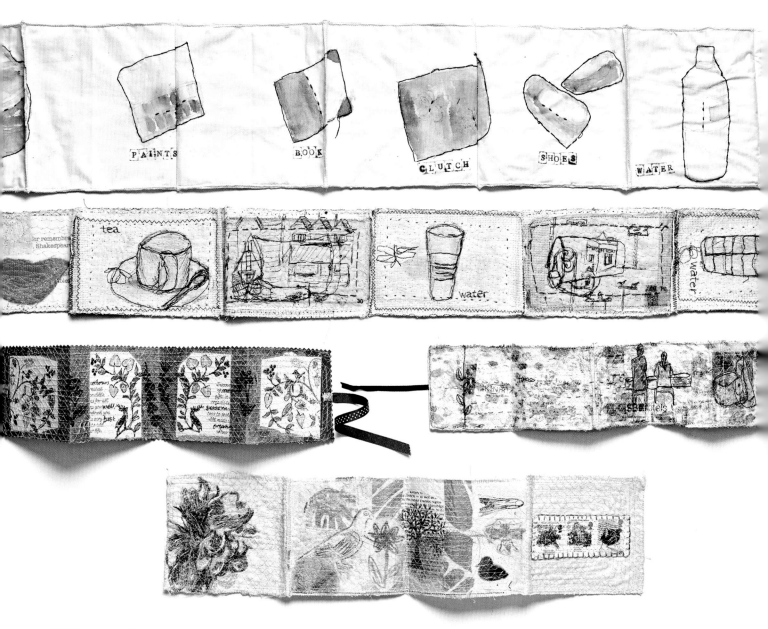

Folding books in
paper, textile and
mixed media.

Making a Folded Book

MATERIALS AND EQUIPMENT

» An old piece of thin shirting or sheeting fabric in a neutral colour for the base, approximately 15 x 45cm (6 x 17¾in). You can also use paper as a background.

» Small scraps or remnants of thin fabrics or papers that complement your colour scheme; organza and tissue are useful.

» Any non-precious copies of images or ephemera (ticket stubs, postcards, maps and so on) from a favourite location or vacation. Poetry describing that place or song lyrics would also be helpful.

» Glue stick

» 25cm (10in) white and coloured tissue paper and/or organza

» Approximately 500ml (17½fl oz) PVA glue

» Water

» Large paintbrushes (house painting ones are fine) or make-up sponges (not natural sponge)

» Iron and ironing board, newspaper or covering for work surfaces, needles and sewing scissors

» Ribbons, buttons and rubber stamps (including letters for words) for embellishing

» Hand-stitching kit (embroidery cotton, needles, pins and so on)

» Sewing machine, sewing cotton, needles and sewing scissors

1 Choose a thin piece of paper or sheeting for your background, and arrange your thin pieces of paper and fabric on it, spreading them out to cover most of the piece. Add your ephemera, poetry and so on.

2 When you are happy with the arrangement, glue them down using a small quantity of glue stick to secure them in place. Don't use too much as it is not good for your sewing machine.

3 Next layer thin pieces of coloured tissue or organza – like 'filters' over your work – once again securing them with a light touch of the glue stick.

4 When you are happy with the look of your piece, you can make a solution of 50 per cent PVA glue and 50 per cent water-mixed well. Brush over your piece, and then lay a piece of thin white tissue paper over the whole work.

5 Brush over the whole piece, taking care not to tear the tissue. Leave to dry, either hanging up or lying flat.

6 When dry, iron on the reverse, protecting the iron and board with baking parchment or an old sheet. Stitch and embellish with pieces of ribbon and hand and machine work.

7 When you have finished stitching, make folds in the book and stitch down the edges to prevent fraying. Then back the piece with fabric and add ribbons for tying. Buttons and any heavy embellishment should be added last.

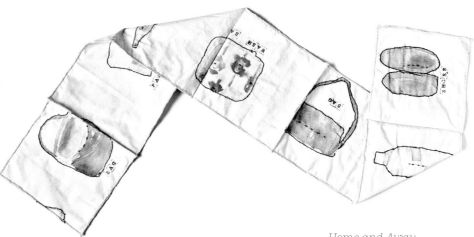

Home and Away, mixed-media folding book with hand stitching on calico.

Bag and Satchel

I have always loved satchels and pencil cases, again identifying them with the quotidian and simple aesthetic of childhood and memory. On a recent visit to Morocco I found these two bags in a market, rather the worse for wear. I decided to re-cover them using fragments of folk-inspired tapestry and embroidery. The satchel is covered with pieces of tapestry, cross stitch and even a small collection of pearl buttons. The bag is mainly decorated with Chinese fabric and embroidery from the markets and souvenir shops there. It is a simpler but effective way to revive an old bag. I used a very hot glue gun and fabric glue to attach the pieces to the worn leather. I stitched the pieces together first after making a template for the shape of the bag. I used a piece of passementerie to cover the edge of the bag and cut holes in the fabric for the straps and buckles. I also made a parrot badge to go with the satchel.

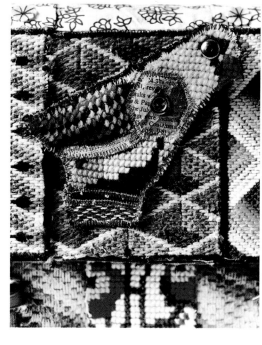

Satchel, mixed media and found folk textiles on leather. The parrot badge (detail above) is a collage of folk textiles and stitch.

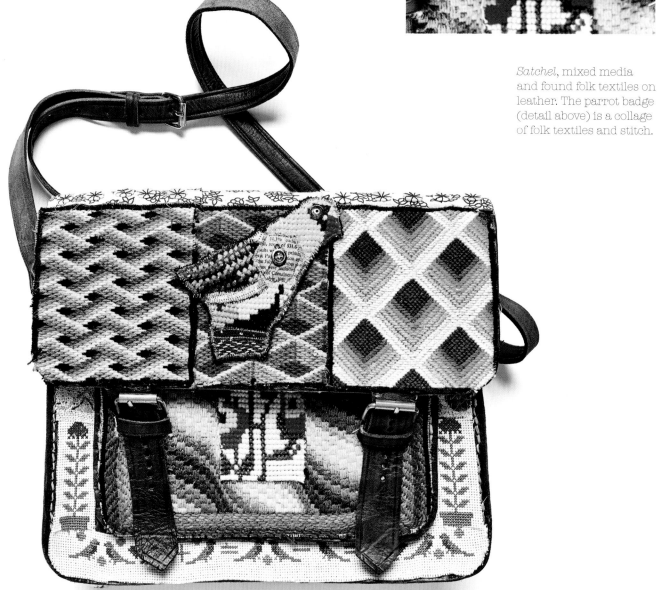

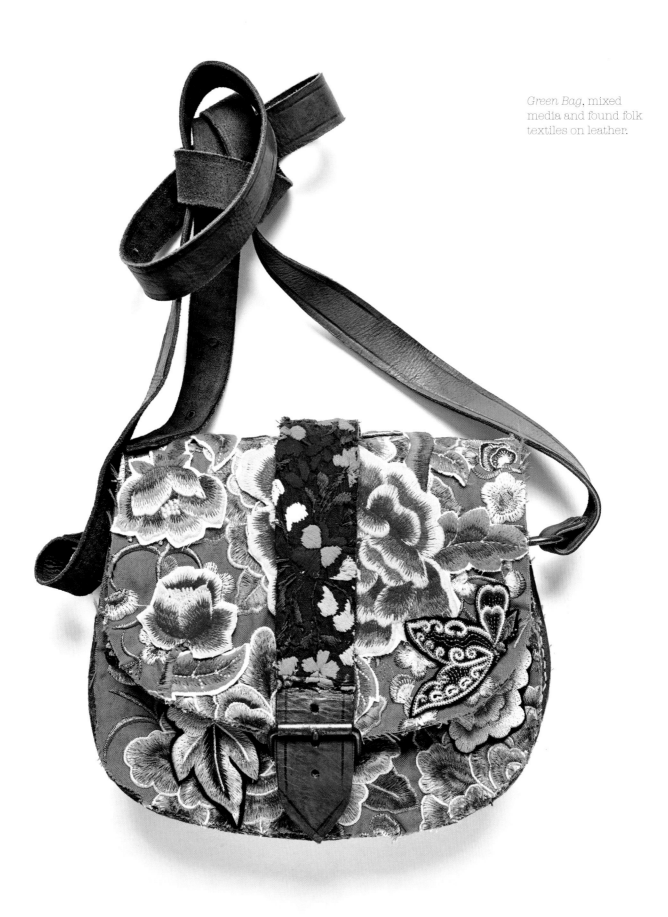

Melanie Bowles

Melanie Bowles is a tutor and textile artist teaching at Chelsea College of Arts. She embroidered *Mexican Flower* as part of her textile residency in Oaxaca, Mexico. The design is based on a traditional Mexican supper cloth she found in the local market. Helped by her embroidery instructor, Estela Antonio, she translated the stitch and created new variations that celebrate the traditional crafts and colour of Mexico.

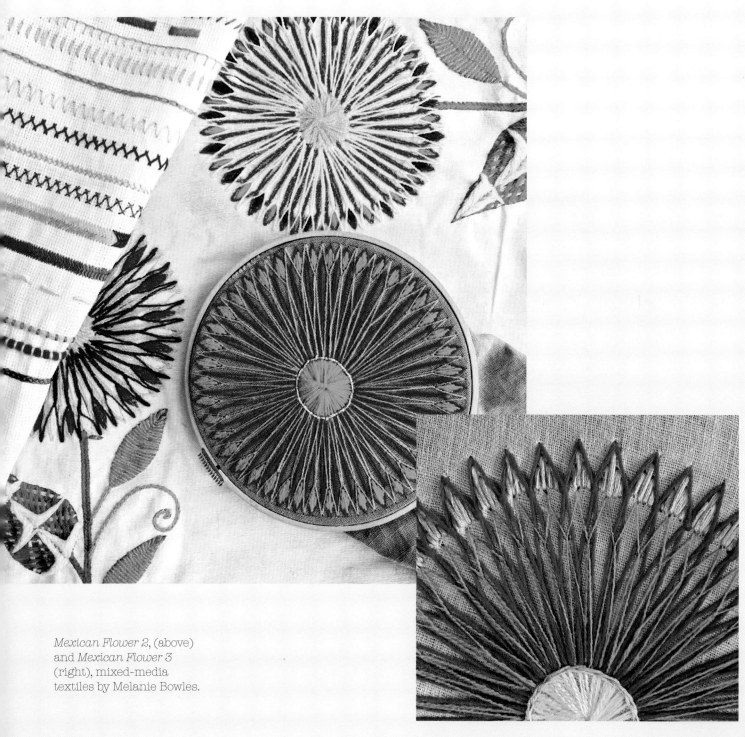

Mexican Flower 2, (above) and *Mexican Flower 3* (right), mixed-media textiles by Melanie Bowles.

Bulgarian Folk Art

Titania Fisher is an embroiderer and tutor who has made a detailed study of folk art embroidery work from Central Bulgaria. These photos show some details from the motifs and designs that she saw there. Here are some of her notes:

'I noticed that the colour red was predominant within Bulgarian textiles. It is believed to have protective qualities, that can bring the wearer happiness, strength and vitality. The textile motifs once had magical significance, but over time this has been forgotten in favour of pure decoration. The symbol of a diamond can also represent a butterfly with immortal and transformative properties. I noticed unusual abstracted motifs upon textile samples, which I learnt were representations of caterpillars, bugs and weevils, stitched onto the cloth in the belief this would keep pests and vermin away. The embroidery within Bulgaria has expansive regional variations and in some villages up to 24 different embroidery stitches are used to decorate traditional folk costumes.'

Photo collage of folk art images from Bulgaria by Titania Fisher.

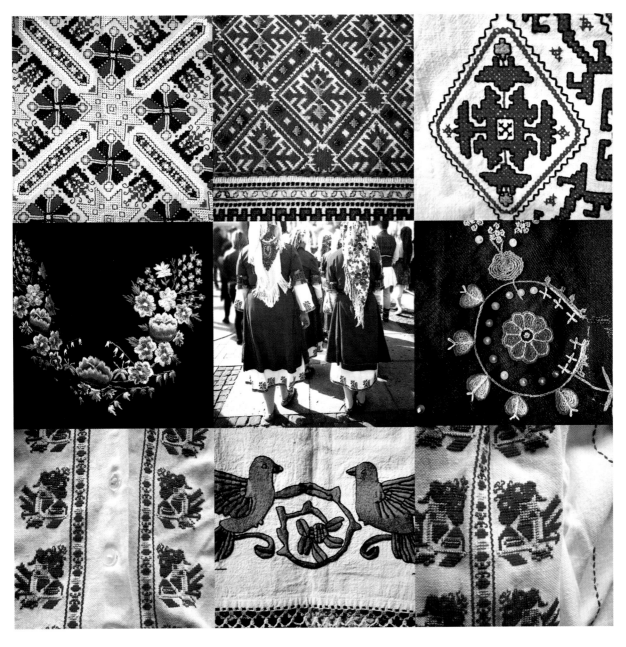

Portrait and Memory

My four-part series of work, *Mon Pays*, was made for the Quilt en Beaujolais event in 2016. It is a series about my childhood in Quebec, Canada, and uses several folk-art motifs and fabrics for borders and backgrounds. Rather than choosing one aspect of my childhood memories to focus on, I looked at old photos, making a self-portrait from one, a landscape of Montreal from another, a memory of the 1967 World Fair (Expo '67) in Montreal and a snowy owl – the provincial bird.

Mon Pays, a series of four hangings, which feature in an installation at Quilt en Beaujolais, France.

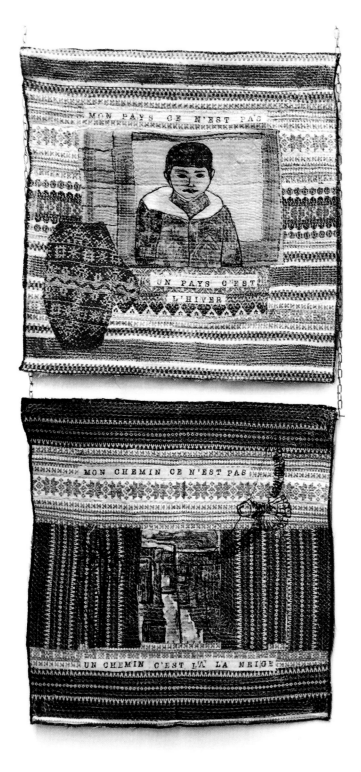

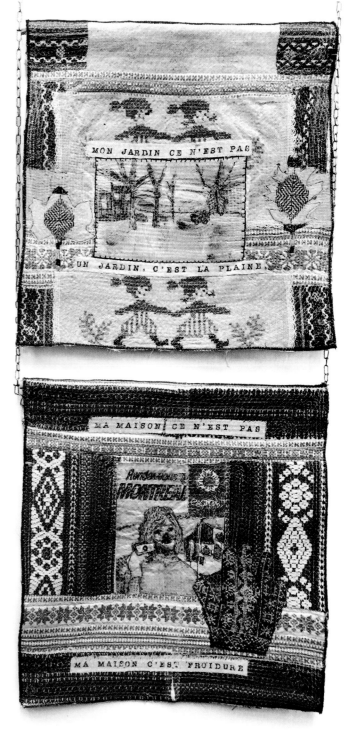

Sue Stone

Sue Stone's work has a nostalgic and vintage feel to it. Expertly crafted and using a subdued palette, I was drawn to this piece that reminds me of a photograph of my sister and I. Sue says:

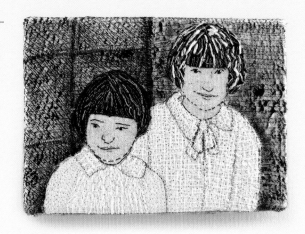

'People, and their relationship to each other provide an important focus for my work. Inspired by my memories, my relationships, my life observations and a pride in my heritage, my work reflects who I am, what I have experienced and how it has affected me. I use images from the family album to create partial narratives that the viewer is invited to complete.

Portrait of 2 Girls, mixed-media textile on canvas by Sue Stone.

'I usually use very simple techniques during the making process. I combine the slow build of hand stitch with the spontaneity of free machine stitch and appliqué. I often use a deliberately limited colour palette to convey emotion and evoke a sense of the passing of time. My stitch vocabulary is very small. My most often used hand stitches are running stitch, backstitch, cross stitch and needle weaving. Paint and dye are often used to stain and to embellish my cloth backgrounds, both underneath and over the top of my stitching, but it is important that the texture of the fabric still shows through.

'Holding the cloth in my hands, whatever form it takes – woven, printed, dyed, already worn – is an essential part of my making process and stitching the cloth helps cement my connection with my work. The cloth has passed through the hands of many people before it gets to me. It already has a history and when I use that cloth I, too, become part of its story.

'As a mainly figurative artist, drawing forms an important part of my practice; it underpins my work but instead of a pen or pencil I use a needle and thread. Usually I draw directly in stitch onto fabric using hand and free machine stitch as a means of mark making. The marks can be drawn, removed, and redrawn, building up the image until it is complete. Rather than being applied to the surface, as with pencil on paper, the stitched marks have an added dimension. They move through the surface, creating layers of texture with needle, thread and fabric, forming an interaction between the maker and made.'

Embroideries, embroidery on textile by Cathy Cullis.

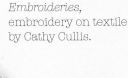

Cathy Cullis

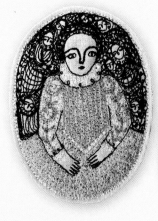

Cathy Cullis is a Surrey-based artist who makes paintings and embroideries. I love this series of small Elizabethan-inspired portraits as they capture the historical look of their subjects while feeling utterly contemporary at the same time. Cathy uses a linen base over which she draws using free-motion stitch. The pieces are then embellished to 'fill in' areas of pattern and colour.

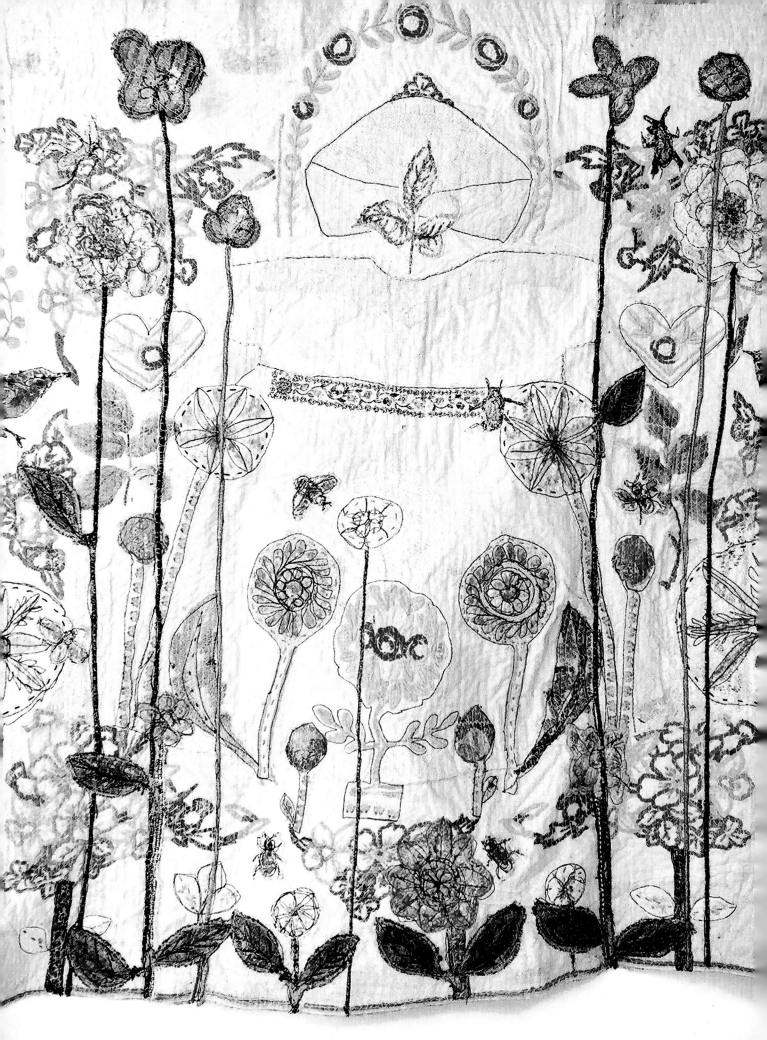

Small Worlds

*'... for creating is the most intense
excitement one can come to know.'*

Anni Albers

Small Worlds

'Small world' is a term once used to describe my work, but I think it encapsulates the density and detail found in many textile artists' work. Making work can often be about creating texture and an interesting surface – but also about drawing the viewer in to observe more closely the details and subject matter of everyday objects. Making smaller-scale work does this very successfully and in this chapter I will look at intricate and small-scale work including badges and patches.

Tree, framed appliquéd and embroidered textile by Nancy Nicholson.

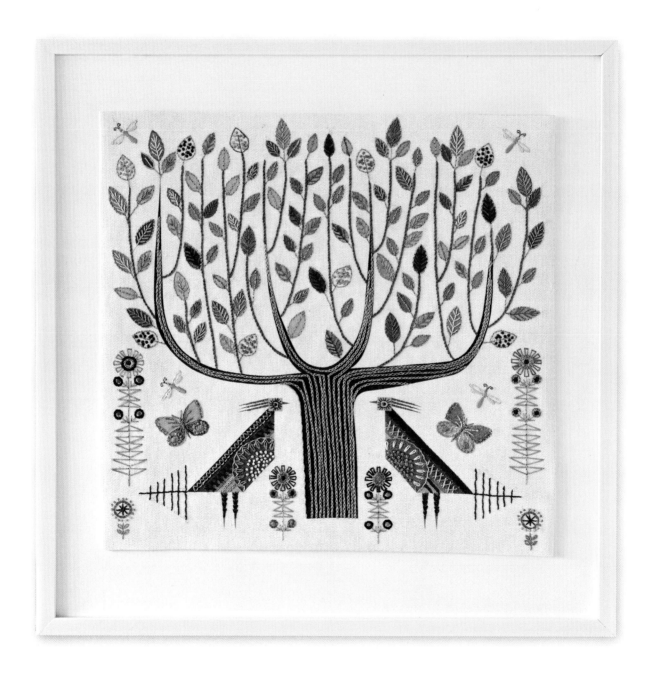

Nancy Nicholson

Nancy is a well-known British artist and designer. She has recently published a book of her designs called *Modern Folk Embroidery* and references folk traditions from many cultures, as well her mother's drawings and designs from the 1960s. Her work is perfectly balanced, fresh and colourful. She uses a good range of stitches in a linear fashion, like drawings, and you can see this clearly in both of these pieces, *Tree* (left) and *Garden* (below). Her designs and kits are sold and widely distributed throughout the UK and abroad.

Garden, framed embroidered textile by Nancy Nicholson.

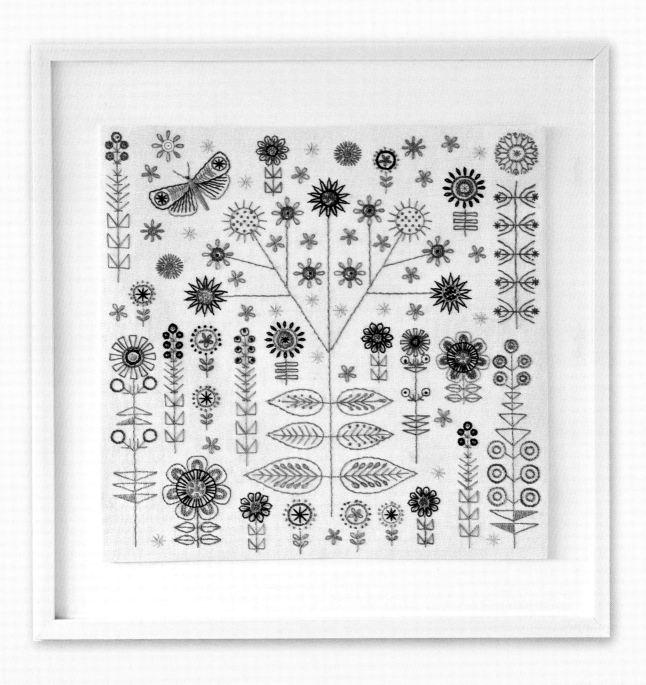

The Tree of Life

The Tree of Life is a common folk motif in many cultures and we can find evidence of them dating back to Egyptian tomb carvings. I like to use them as a structure to create a composition that can be added to. The branches create a linear space in which other objects can be situated. Often the tree itself becomes obscured when the piece is finished, as the objects overtake its shape.

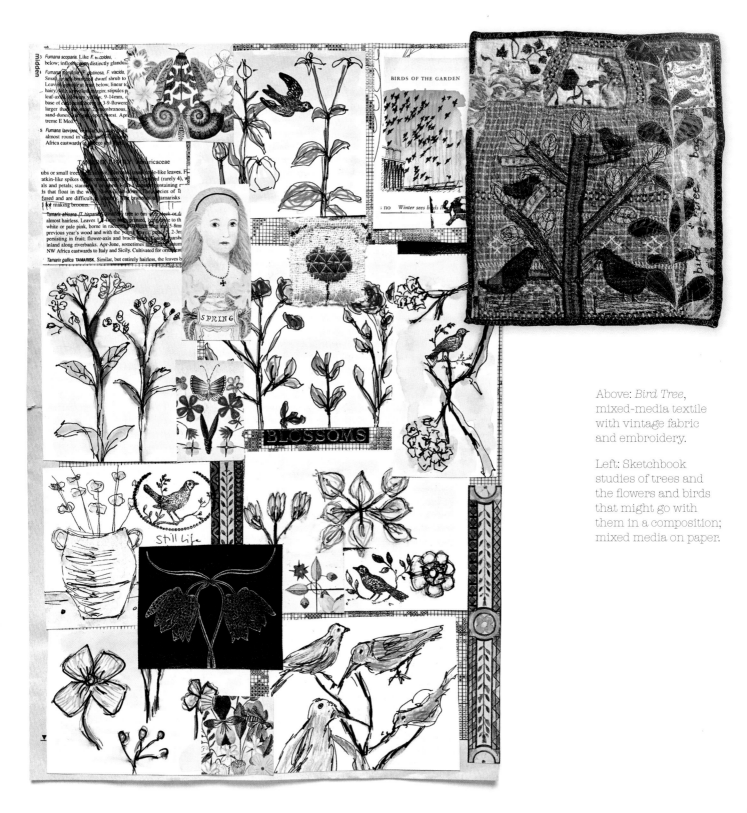

Above: *Bird Tree*, mixed-media textile with vintage fabric and embroidery.

Left: Sketchbook studies of trees and the flowers and birds that might go with them in a composition; mixed media on paper.

Christine Atkins

I taught with Christine Atkins in Australia and we were housemates during our teaching in New Zealand. We had fun searching through 'op (opportunity) shops' (charity shops) near our accommodation, both for different things. Christine uses an alchemic combination of textile and sculpture to create her trees of life. She says:

'With having spent much time as a child in the Australian bush came the need to construct games and toys from what was around us. This included sticks, mud, parts from an old rusty car or whatever else we could find … always imagining what each treasure could be used for. In many cases, after being left for some time, nature had begun to take over the discarded object, growing through or over it. These images stayed with me, and it is this interplay between us and the natural world – its importance to us and our impact on it – that inspires my work. With an emphasis on the ordinary, taken for granted or discarded comes an invitation to 're-appreciate' the often-overlooked natural world around us.'

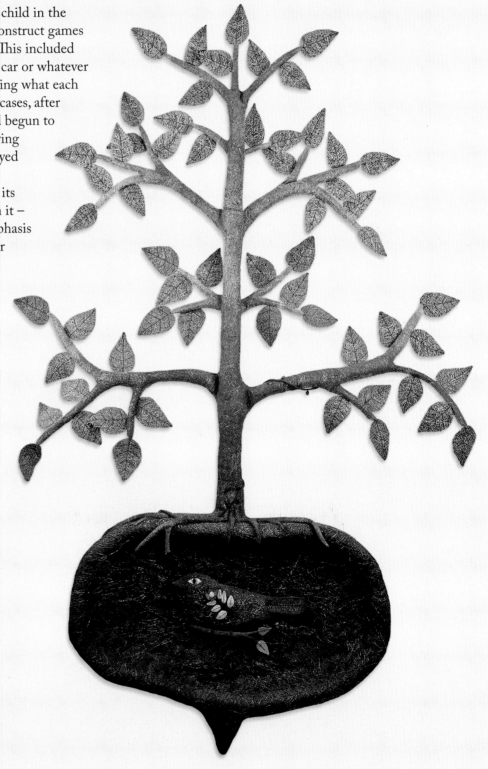

Shelter, thread and Guildford grass (*Romulea rosea*) by Christine Atkins.

A Folk Tree Collage

MATERIALS AND EQUIPMENT

» Strong piece of fabric (calico, light canvas or linen union), roughly 30 x 30cm (12 x 12in)

» Scraps of vintage fabric and/or embroidered pieces to decorate and embellish the background and the tree

» Fabric pen/chalk

» A selection of ribbons, strips of fabric or string and buttons

» Embroidery cotton

» Hand stitching kit

» Glue stick

» Wooden blocks, stamps or stencils

» Printing ink or stencil paint

» Sponge (synthetic)

» Scissors

» Sewing machine and kit if required

1 Select the size and shape of background you want to use. If this is your first piece, choose a small scale piece until you have tried the techniques involved. You need a strong, stable piece of fabric – calico, light canvas or linen union are ideal.

2 Select some thin and subtle elements from your vintage fabric and embroidered pieces. These can be tacked down onto your background.

3 Draw a simplified tree outline on the background fabric. Cover the tree outline with a variety of ribbons, strips of fabric selvedge or even string. Tack them on, using a colourful piece of embroidery cotton. Treat the tacking as part of the design and then it won't need to be removed later on.

4 You can add small fabric pieces to the trunk and branches at this stage. Attach them to the tree with a light touch of a glue stick. This will hold them in place and when dry you can tack them on again, using a complementary thread or embroidery cotton. For the leaves, folded layers of fabric cut in a leaf shape make a good addition to your piece. You can also use scraps of embroidery.

5 Add interest to your collage by printing birds and flowers onto separate pieces of fabric with block prints, using wooden blocks and the stencilling paints with a piece of sponge. Dab lightly onto the blocks or rubber stamps and press onto the fabric using a rocking motion. When they are dry you can embellish them and cut them out, attaching them to the tree.

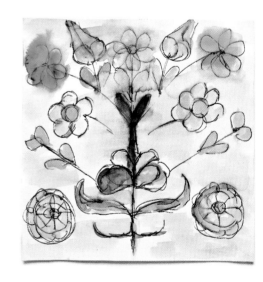

Folk Tree designs, pen and watercolour on paper.

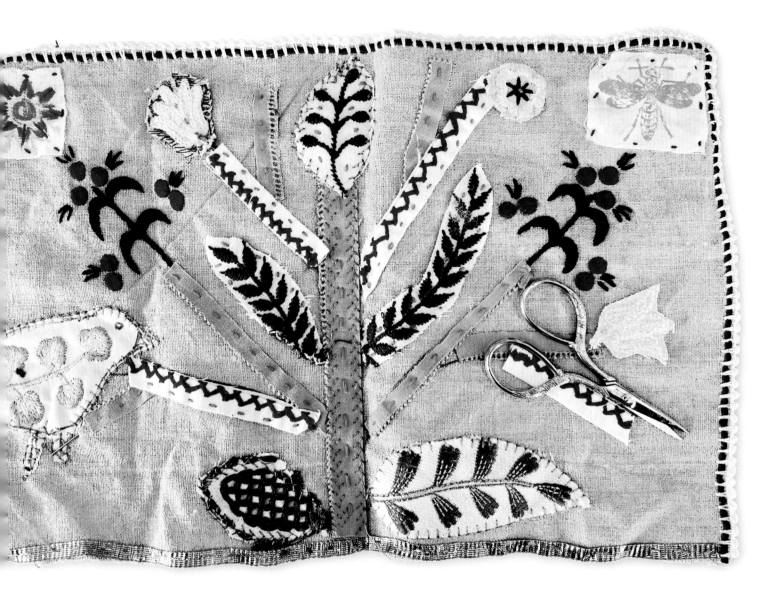

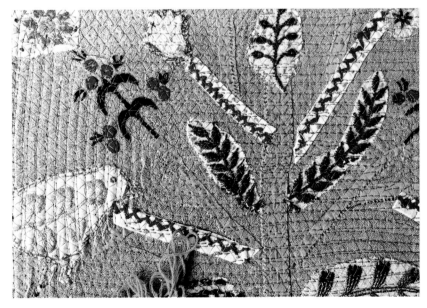

Folk Tree, textile work in progress (above), and a detail of the finished piece (left).

6 At this stage you can add ribbons, buttons or other embroidered elements to your piece, and consider which areas you would like to hand stitch. The more elements that you add, the more interesting your piece will become. Hand and machine stitching add texture and depth. Try kantha or seed stitch in the background.

Folk Tales Workshop

I had a wonderful teaching tour in Australia and New Zealand and had some very enthusiastic and talented students. I gave the same workshop three times. *Folk Tales* was a four-day workshop that enabled the students to work on a larger scale. The emphasis was on using vintage/charity pieces of textile and embroidery using the tree motif. As an added challenge, students also made a small folding piece to add in a 'pocket' on the finished work.

Kerry Douglas' piece (below) took inspiration from *Glove Forest* (see page 82) and used an old green glove belonging to her mother as the 'tree' (shown on the far right). Her finished piece was exhibited in a textile exhibition after the workshop.

Above: Mixed-media textile on vintage cloth by Barb Jebs.

Right: Detail from a mixed-media textile on vintage cloth by Kerry Douglas,

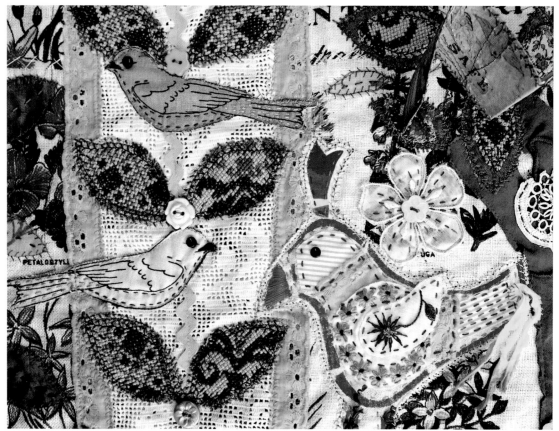

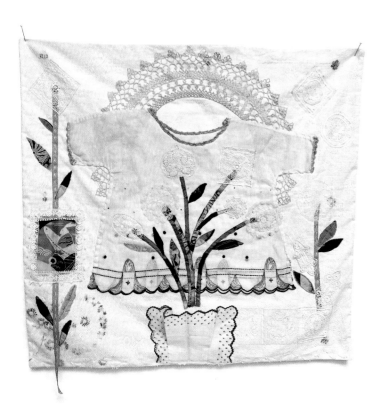

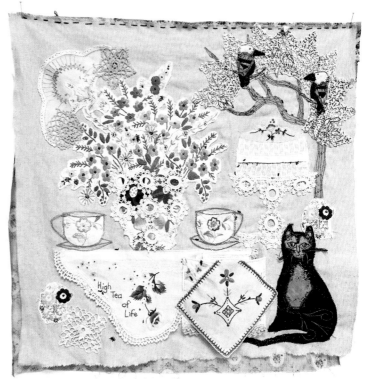

Elizabeth Dubbedele is an Australian textile artist and organizer of the Berry Quilting Retreat, an annual textile festival in New South Wales. I taught there when I was in Australia and Elizabeth decided to join my class in Ballarat, Victoria. She made the beautiful and delicate piece shown above left using a much-treasured dress from her aunt who died tragically young, with lace and Japanese fabric.

Susan Greaves was also in the Ballarat class, and made the charming piece above right using table napkins, pieces of embroidered fabrics and some inventive animals from her own drawings. She entitled it *The High Tea of Life*.

Above left: Mixed-media textile on vintage cloth by Elizabeth Dubbedele.

Above right: Mixed-media textile on linen by Susan Greaves.

Below: Mixed-media textile on linen by Felicity Willis.

In New Zealand the work was equally successful. Felicity Willis, who is the author of *The Decorative Stitch* about New Zealand embroidery, made the lovely piece shown right using a Chinoiserie-inspired border from her Mum, and added the cockerel.

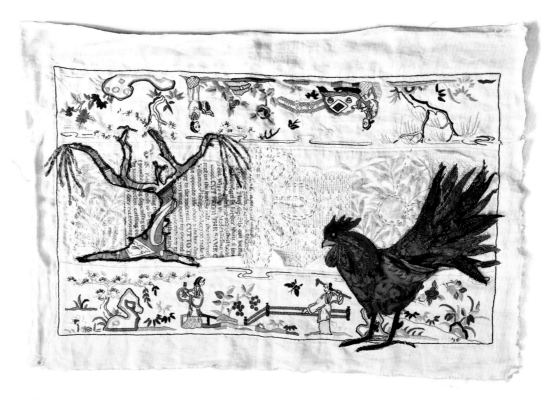

Glove Forest

Glove Forest is an example of how old garments can be re-purposed. An old school friend gave me her grandmothers' collection of kid gloves. While it may seem shocking to some to have cut them up, it was blissful drawing and stitching on them as otherwise they would have ended up in a charity shop.

I used permanent marker pens to draw the details on the gloves, which have been cut in half. I laid them out on a fabric background, pinned to the surface and then overstitched them using my sewing machine. This overall stitching acts as netting and holds the different layers and elements together.

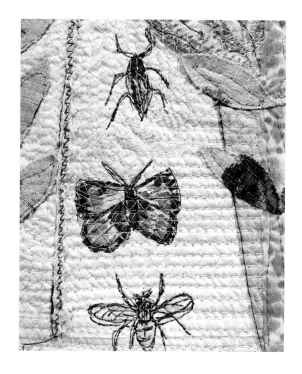

Glove Forest (below) and detail (right), mixed-media textile.

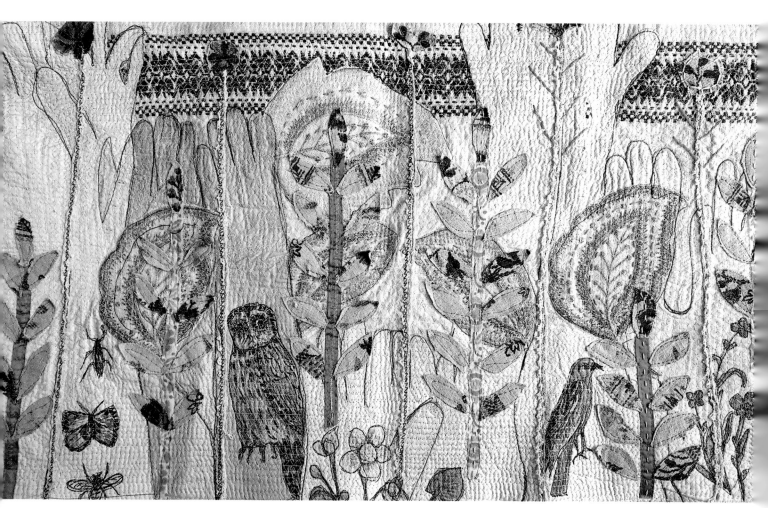

Badges

Stitched badges are powerful despite their size, as they often capture the essence of a maker's work. They can have a folk quality to them since they are often simplified versions of larger pieces. Badges act as 'small samples' of a technique, image or theme. They can be worn on garments or bags and used as patches for embellishment or to refresh and re-purpose other items.

The badges shown on the bag below are gifts from my collection and have inspired me to make further projects. The two metal-framed pieces are from charity shops. The felted flowers are from Japan. The portrait was a gift from a visitor to the Knitting and Stitching Show in London, the bird is made by Katarina Thurell from Sweden and the owl is by Laura Marriott, who is featured on page 87.

Badges on a Chinese embroidered bag from the author's collection.

83

Doris Benjamin

This amazing nurse's cape was decorated with 177 badges by Doris Benjamin. She was a military nurse with the Voluntary Aid Detachment (VAD) during the Second World War and collected these badges from the soldiers she treated. Many are charming and simply made, and come from all over the British Isles. They include a seagull badge for the Faroe Islands Force, a black cat (a lucky character in a folk tale based on Dick Whittington) for the 56th London Infantry and a penguin for the 22nd Beach Brigade. The cape is on display in a three-dimensional case at the Jewish Museum in London so it is possible to see all sides of it.

Cape with Badges, by Doris Benjamin, from the Jewish Museum in London (loaned from the Jewish Military Museum).

Hand & Lock

As I find badges so inspiring, I wanted to do some research into their history. Hand & Lock are a venerable company, founded over 250 years ago, and specialize in hand-embroidered and traditional badges for military and civilian use. I attended a recent exhibition of their collection in London and was impressed with the quality of the intricate handiwork involved.

I was invited to their head office in London to take photographs of a selection of their current badges. Many involve painstaking wirework (goldwork) and are now made in India.

Selection of badges from Hand & Lock, in silver and gold wire and stitch on fabric.

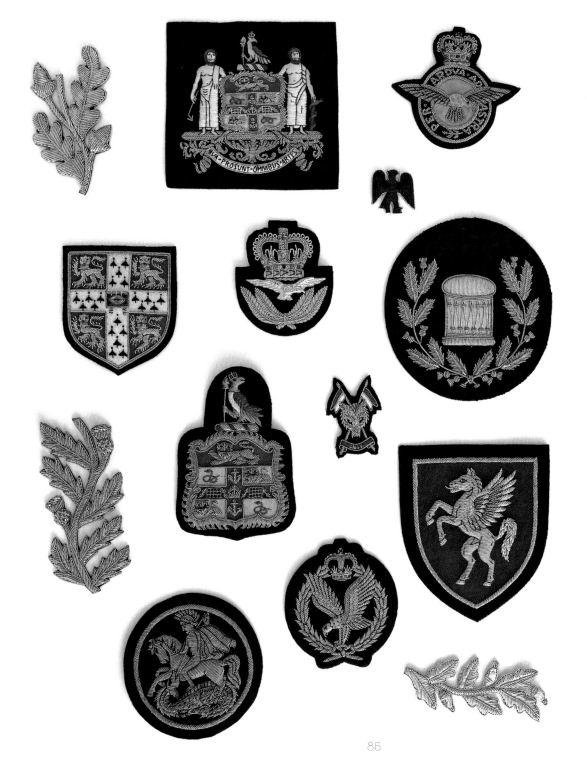

Ellie Macdonald

I discovered the work of Ellie Macdonald on the social-media platform Instagram. Based in Brighton, UK, she makes beautiful embroidered patches and badges and says:

> 'I work predominately on a vintage freehand Singer machine, it's a great machine for creating the illustrative, almost hand-drawn style that I love. The patches started from a desire to create a small and affordable product that I could sell. The themes come from all over but mainly nature and current trends. Many involve painstaking wirework and are now made in a London studio and Indian factory.'

Jacket by Ellie Macdonald. Embroidered patches (shown above) on a denim jacket.

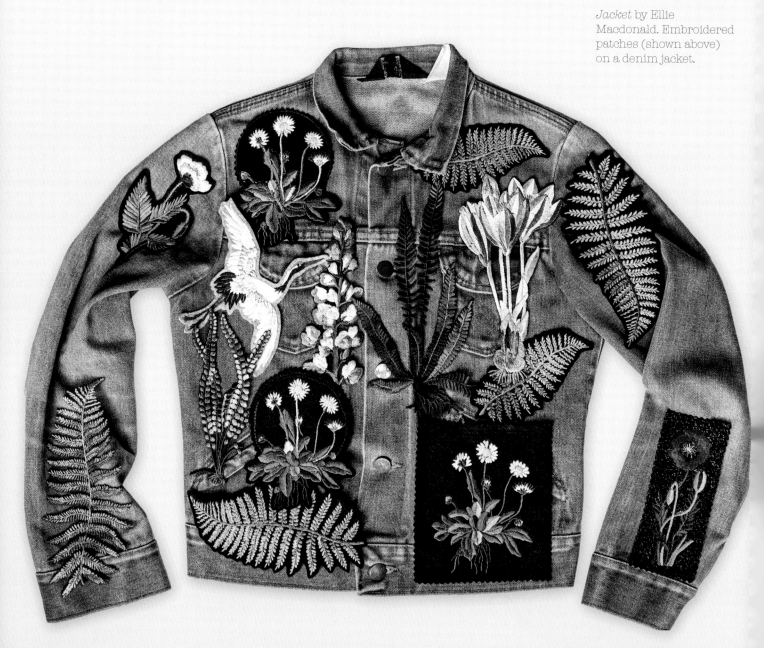

Laura Marriott

Laura Marriott is a recent graduate and was a featured new designer at the UK Knitting and Stitching Shows in 2016. She says:

'I am an illustrative textile artist with a passion for experimenting with layers of stitch, colour and pattern. I specialize in producing unusual and exciting creations, through digital embroidery; and crafting these materials into three-dimensional forms that are combinations of contrasting shapes and textures.

All my work is inspired by my travels around the world; as I continue to explore, my design inspiration and imagery grows – creating a visual map of my journey. This exploration ranges from crowded British cities to remote villages in Botswana, and everything in between!'

Her current work ranges from statement jewellery, such as quirky individual patches and brooches to large framed artwork that incorporates her more three-dimensional creations. Her small works are badges and her unusual shapes and colours coupled with precise embroidery create unique and striking designs.

Beetle Flower (left) and *Mask Beetle Flower*, (right), mixed-media textile by Laura Marriott.

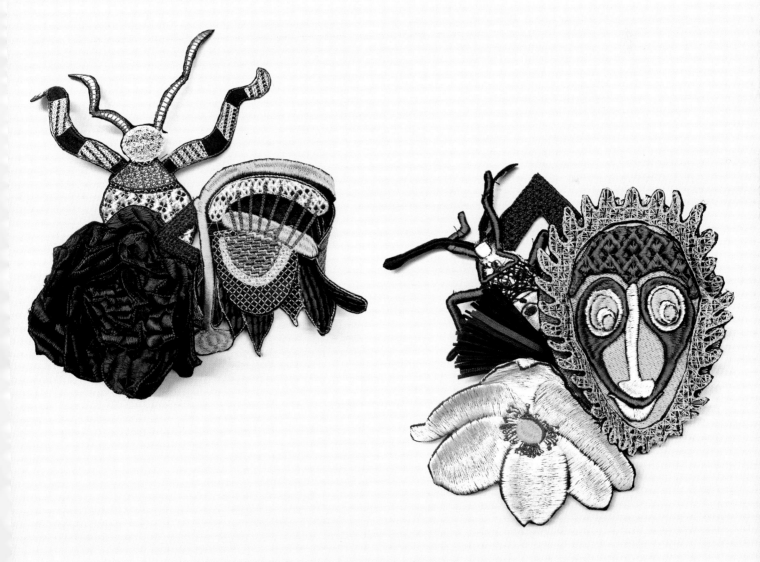

Antipodean Journeys

I made three pieces from my travels to Australia and New Zealand using vintage tea towels as a base. I wanted to use them as colourful backgrounds and memorials to document my journey abroad.

The first *Journey to Australia* combined many pieces of recycled embroidery and some contemporary badges to illustrate in a simple and graphic sense the journey I took via Hong Kong. I used a mixture of vintage and found textiles to create the story. Lettering came from a piece of cross stitch that I cut up to spell the words. The finished piece was backed and overstitched (see below right).

Postcards from New Zealand is based on a tea towel donated by my students and has some vintage badges I found in a charity shop in New Zealand. I added small baskets found at a budget shop as the tradition of basket-making is very strong there. Once again, the piece was framed and backed with New Zealand fabric.

Below: *Journey to Australia*, shown in progress (left) and completed (right).

Right: *Postcards from New Zealand*, mixed-media textile.

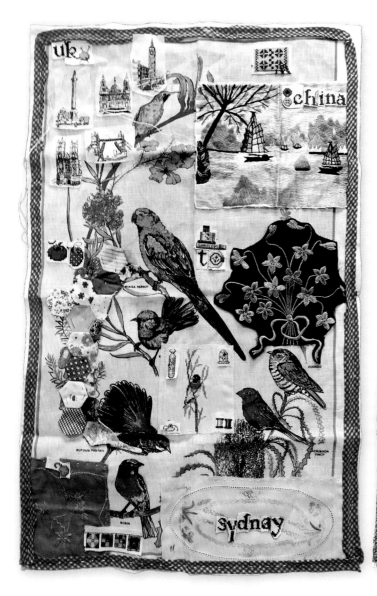

Birds and Bugs

The third piece in my Antipodean collection, *Rainbow Lorikeet,* is also based on an old tea towel and shows the amazingly colourful bird that is quite common in Australia but very striking to the visitor. I was amazed to see a real lorikeet in Sydney on my first day there. I found a linen tea towel in a charity shop in Canada (made in Poland – truly multicultural!) and I covered the existing design with small pieces of cloth and added pieces of tapestry as well. I also added pieces of needlepoint, again sourced from charity-shop visits. I then overstitched the piece by hand and machine and added a backing cloth.

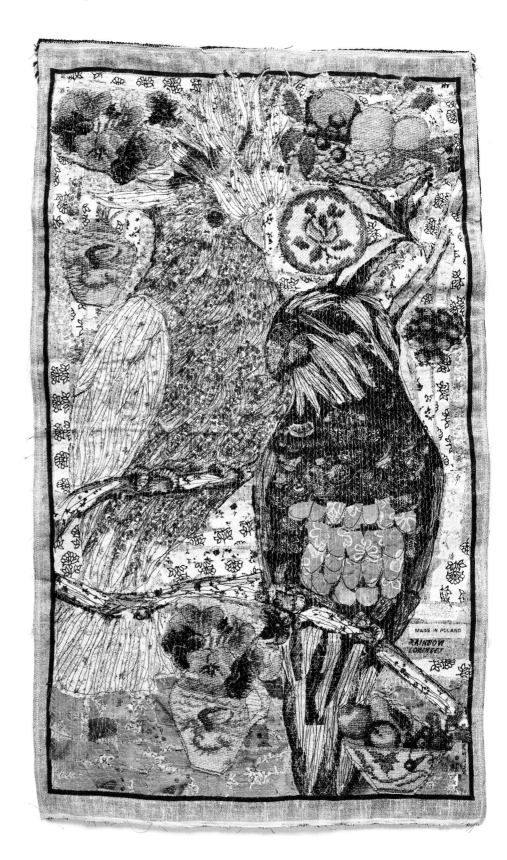

Rainbow Lorikeet,
mixed-media textile.

I was delighted to take part in the *Page 17* exhibition hosted by the Embroiderers Guild in the UK in 2017. The work exhibited had to bear a strong relationship to a book chosen as inspiration – it could be from any part of the book, it did not have to be page 17 specifically, and any kind of book could be chosen – fiction, poetry, recipes, maps, catalogue or instruction manual, for example.

While teaching in Australia, I came across a copy of *The Book of Common Insects*. I decided to make a piece based on the book, using small fabric cut-outs of insects superimposed on written pages. I used the book cover as a frame to mount the embroidery in.

Everything, from the wooden frame which the entire piece is mounted on, to the beetles that have been covered in tapestry, the ribbon, measuring tape, buttons and beads, were found in charity or 'op shops' as they are called in Australia. I see the piece as a celebration of upcycling and entomology.

A Book of Insects – Common, mixed-media textile (left) and a flock of inspiration from the author's collection (above).

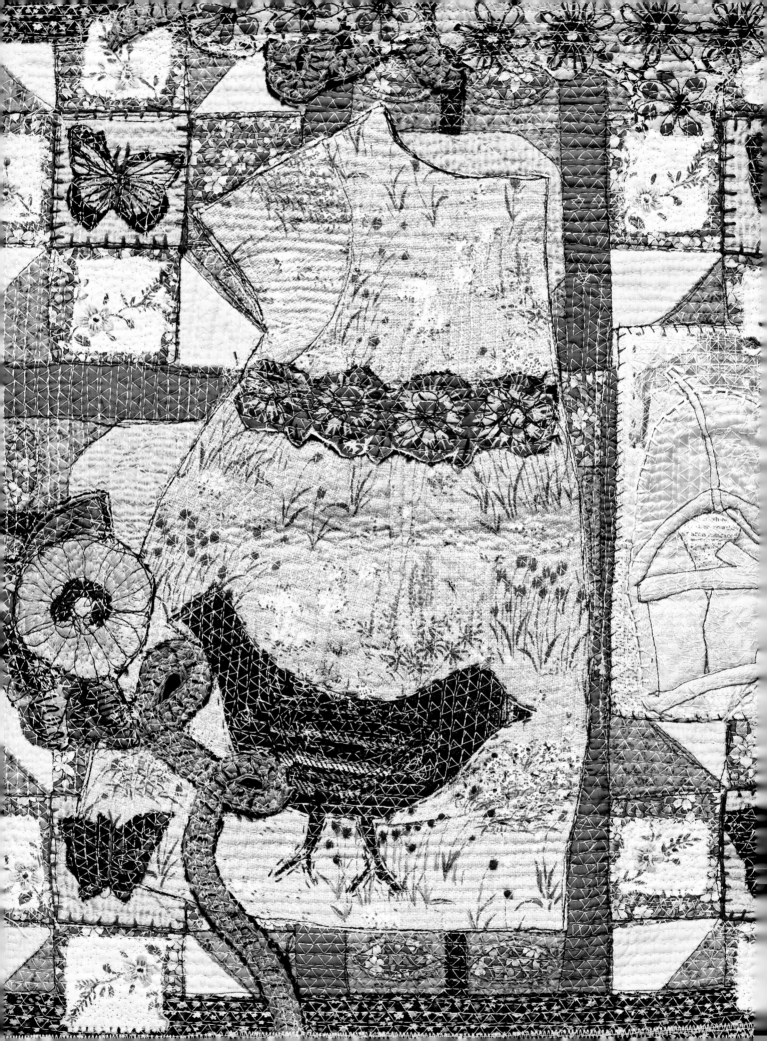

Home and Childhood

'Look at everything as though you are seeing it for the first time, with eyes of a child, fresh with wonder.'

Joseph Cornell

Black Bird and Dress, mixed-media, textile.

There's No Place Like Home

The purpose of much historical folk art was to decorate and celebrate the home, so it is natural to look at the links between them. Quilts, samplers, pictures and artefacts all exist as a part of this domestic world. Contemporary artists are frequently drawn to themes and narratives about the home to create original works and often reference them in their studies.

This *Pedlar Doll* was found in Opendrawer, a gallery and textile emporium in Melbourne, Australia. It is a collage using many vintage items of haberdashery including lace, buttons and a measuring tape. Everything has been wrapped around or mounted on a wooden cut-out in the shape of a doll.

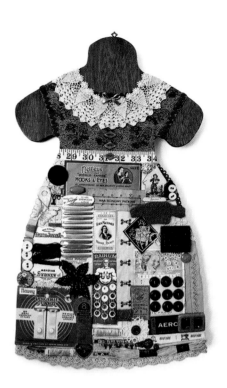

Quilts

Communities in North America used quilting as part of their rituals and identity, none more so than the Amish of Pennsylvania. It is still possible to see members of the existing communities working on quilts today. I saw some stunning examples of contemporary and vintage Amish quilts collected by Jacques Legeret at the festival of Les Aiguilles en Luberon in France, where I exhibited. My work was in the same village as these quilts and it was wonderful to be able to see them up close. The colours are striking and vivid, many years after being made. They act almost as abstract paintings in some cases.

Pedlar Doll by Jan Harris, mixed media on wood.

Left: Detail from *Spinning Stars*, a c.1890 Amish quilt. (Collection of Jacques Legeret).

Right: Detail of *Broken Star*, by Melinda Blank, old and new wool fabrics. (Collection of Jacques Legeret).

Quilt Inspired

I used a damaged vintage Welsh quilt as a background for six individual embroidered pieces. *Natural History Quilt* was first shown at the London Knitting and Stitching Show. The quilt was a good blank canvas on which to display the embroideries, all based on natural themes.

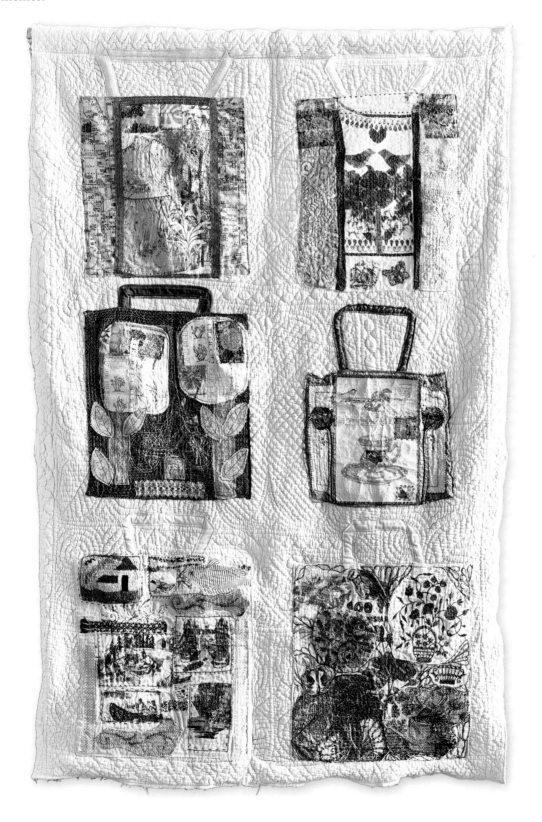

Ann Wood

Ann Wood is a Brooklyn-based textile artist who makes charming small objects and works of art including small creatures and dolls. She also sells patterns and kits. I was drawn to her illustrations that are very folk-art inspired and strong pieces in their own right. The black outlines make them feel simple but the skill involved in the painting belies this. Ann's studio is an inviting and homely space – the perfect setting for her creations. These paintings have a vintage feel and her use of colour adds to their character.

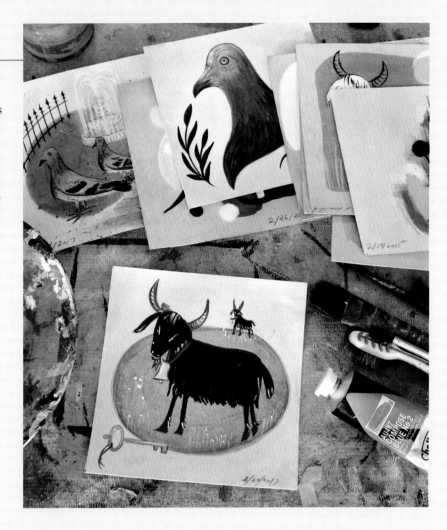

Illustration by Ann Wood, mixed-media on paper (left) and her work in the studio (above).

Working to Commission

I was commissioned to create a piece using textiles that came from the family, which is an excellent way of making a memento with true personal resonance. The family are French/Romanian and live in London. Their textiles were worked by a relative and are precious in their own right. The colours were primarily blue and red so I used these colours throughout.

Romanian Commission, mixed-media textile.

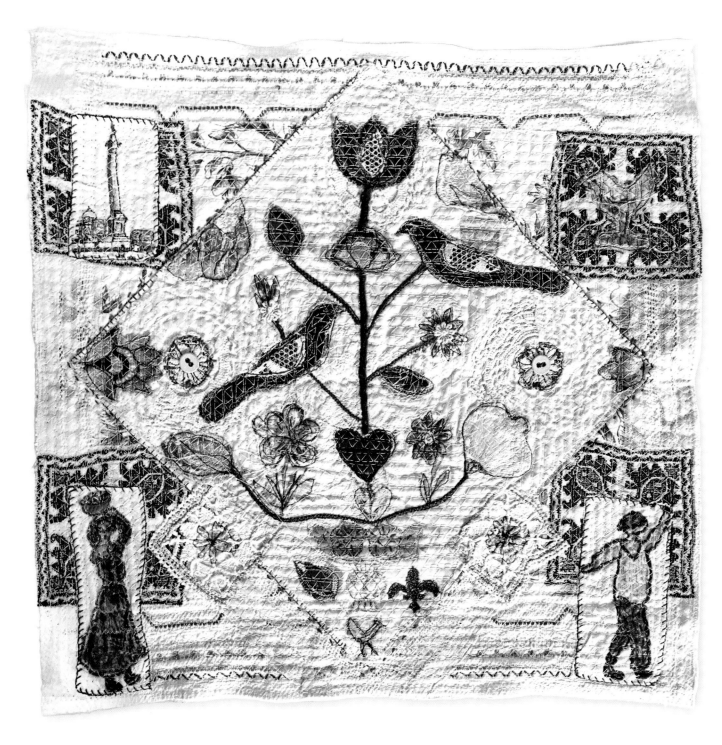

1 To begin with, speak to your client and establish the size and shape of the work; the main colours; and the subject matter – shapes, figures, writing and embellishment.

2 Using the above, provide an estimate based on size and complexity. Be as clear as you can about timings and materials. I don't charge for materials but incorporate them into the price of the piece. Ask if the client needs an outline sketch/design or is happy for you to proceed. I send photos at different intervals during the process to gauge opinion.

3 At the preliminary meeting I bring samples of previous work, textiles available from my collection that I think might go with the piece and a sketchbook and pen, or tablet, to take notes and make suggestions.

4 I make a life-size scale outline drawing or template in black and white before I begin. This is used as a reference and is helpful when cutting out main shapes. I prepare the background first, making a richly textured base using preferred colours. I find that this gives me a head start when it comes to the rest of the piece. The more interesting your background, the less you have to do on top.

5 Once I am happy with the background, I use a glue stick and pins to position the main shapes and attach them to the base fabric. Then I tackle the main pieces of the commission. These can be worked on separately and added to the piece when finished. They are easier to manoeuvre away from the background. When finished, the main pieces can be added to the background.

6 I then proceed to the embellishment stage when writing, ribbon, buttons, photo transfers and so on, can be added. Often artists prefer not to accept commissioned work as it can become unrepresentational of their oeuvre. However, I like to work with the person commissioning the work and enjoy creating new works of art from old textiles.

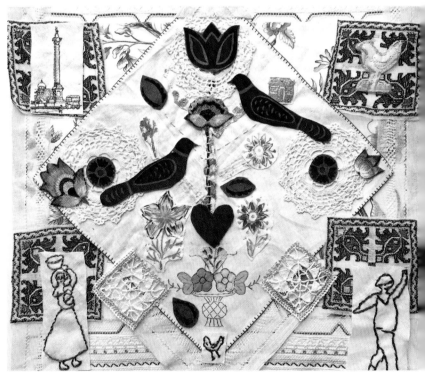

Top: Fabrics for the commission in the artist's studio.

Above: *Romanian Commission*, work in progress. The finished piece is shown opposite.

National Needlework Archive

The National Needlework Archive has a large collection of work and publications and I recently held an exhibition of folk art textiles there, teaching a workshop as part of the exhibition. Here is what director Linda Connell has to say about some of the folk-themed pieces:

'Inspiration is everything, and looking at books and magazines is a great source of ideas. Old books and magazines are brilliant for designs and suggestions just crying out for updating and recycling.

Right: The *Folk Tales* exhibition at the National Needlework Archive in Newbury.

'There are several libraries in the UK that have good textile sections and the National Needlework Archive, based in Newbury, Berkshire, has a dedicated textile reference library which includes books and magazines.

'Keep an eye on your local charity shop for easily available *Golden Hands* magazines and publications. Popular in the 1970s and '80s, these magazines and similar titles were full of projects and patterns that make a good basis for folk-art treatment. Older magazines are harder to come by but those from the 1940s and '50s have lovely patterns for hand embroidery and crochet which can be worked directly on art pieces themselves, or worked separately and then cut and reworked into a finished piece.'

Left: Selection of vintage folk-themed magazines from the National Needlework Archive.

House and Home

Houses are potent symbols and are often used and subverted in all areas of art and design. Here are some examples of inspiration for them – a fabric collage, an embroidered house, a patterned fabric and a small painting.

I went for a study visit to the Museum of Childhood in Bethnal Green. I was keen to see their doll's house collection as it is renowned and covers quite a large period of doll's house manufacture. When I was at the gallery there was a wonderful installation, *Place (Village)*, by the contemporary artist Rachel Whiteread of a doll's house installation. She collected the doll's houses and arranged them in a stacked shelving display. She was inspired by the collection at the museum, which she visited as a child, and later as an adult.

House inspiration, author's collection.

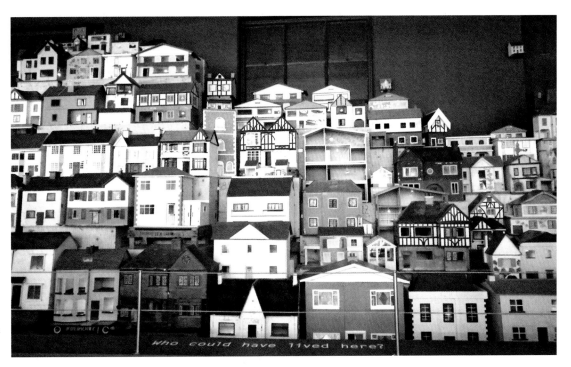

Rachel Whiteread, *Place (Village)* doll's house installation, V&A Museum of Childhood.

Folk Doll's House

My *Folk Doll's House* was inspired by a collection of brocante fabrics I found at a charity shop in France. The small doilies all had simple images of birds embroidered on them. When I returned home to the UK I found the doll's house in a charity shop – it was painted pink. I covered the doll's house inside and out with paper from vintage books. I used a 50:50 mixture of PVA and water to coat and apply the pages, much like wallpaper.

I then used a mixture of ribbon and lace scraps to decorate the front of the house, around the windows. When this was dry, I started to tackle the ends, back, roof and sides of the house, spacing the brocante pieces so that they are visible but not too crowded. I added some vintage ribbon and card pieces to the finished design. Inside I 'hung' a small piece on canvas on the wall. Apart from that, the house is quite sparsely furnished to allow the viewer concentrate on the decoration. When everything had been applied with glue and glue gun, the whole piece was varnished again with diluted PVA, which gives it a unified feel.

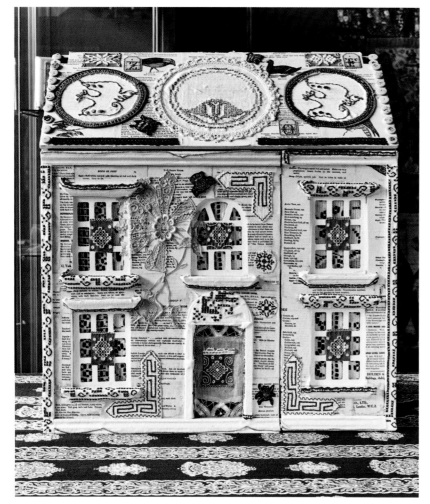

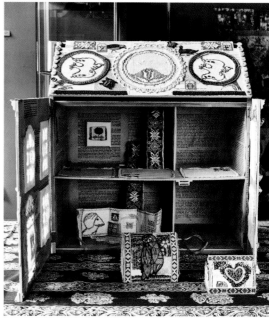

Anne Kelly, *Folk Doll's House*, mixed media, brocante fabrics and pages from vintage books on wooden doll's house.

Deena Beverley

Deena Beverley was one of the first visitors to my exhibition at The Old Chapel Textile Centre and reviewed it for her column on the Mr X Stitch blog run by Jamie Chalmers. She was inspired to create a three-dimensional piece called *Finished Unfinished* for the Folk Art Doll's House. Her words describe her process and the intention behind the work:

'I gathered newsprint from a late relative's sewing trunk and selectively harvested text for meaning. I hand stitched the quilt while sitting on my bed. As I stitched, I contemplated the paper's insulating properties, feeling fortunate to have moved on from equally sudden and unexpected homelessness in my youth. The miniature bed, a charitable donation, was given to me during my voluntary work. It was deemed too damaged to sell so I repaired it and used it here. Essentially, it's bandaged together with decoupage. The Green Shield stamp quilt was inspired by discovering in interviewing Anne that she'd been the recipient of a Green Shields Foundation Award. I loved that this had helped progress Anne's creative journey, and that these ephemeral items link so many of us in memory and tale. I picked up threads, paper and rusty metal from the floor and the street and, as in Indian work, use threads drawn from the weave of old fabrics for stitch. Even the glue and ribbon for this quilt were donated and the lace was a charity-shop find. That these materials have passed though many hands, and that now I am passing on this object to Anne for collaborative use, to be enjoyed and shared with others, is hugely important to me.'

Finished Unfinished by Deena Beverley. Mixed media including vintage newspaper, silk ribbon and thread, lace, and Green Shield stamps on wood.

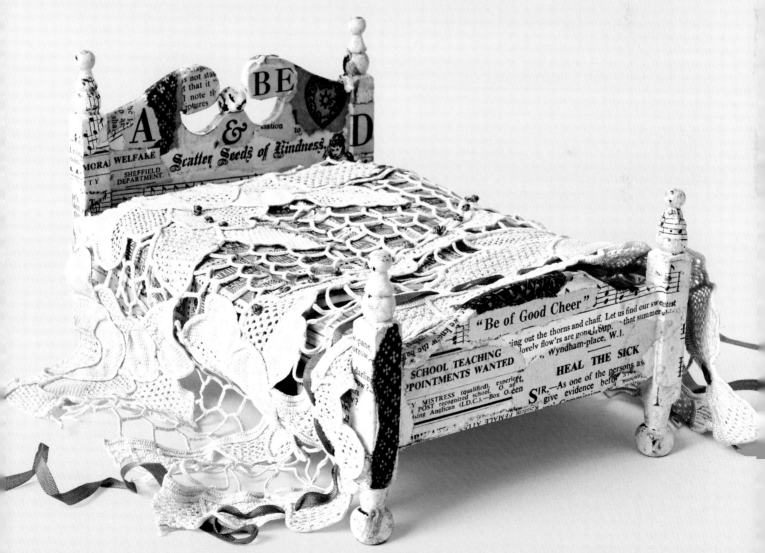

House Collage

I was given a lovely collage by a friend. It is a true piece of folk art, made from remnants of suiting fabric and minimal stitching. In this mini workshop, I am using scraps that I have around the studio to make this piece. It's a great project to give as a gift for a special occasion.

*House Collage,
mixed-media textile
and paper.*

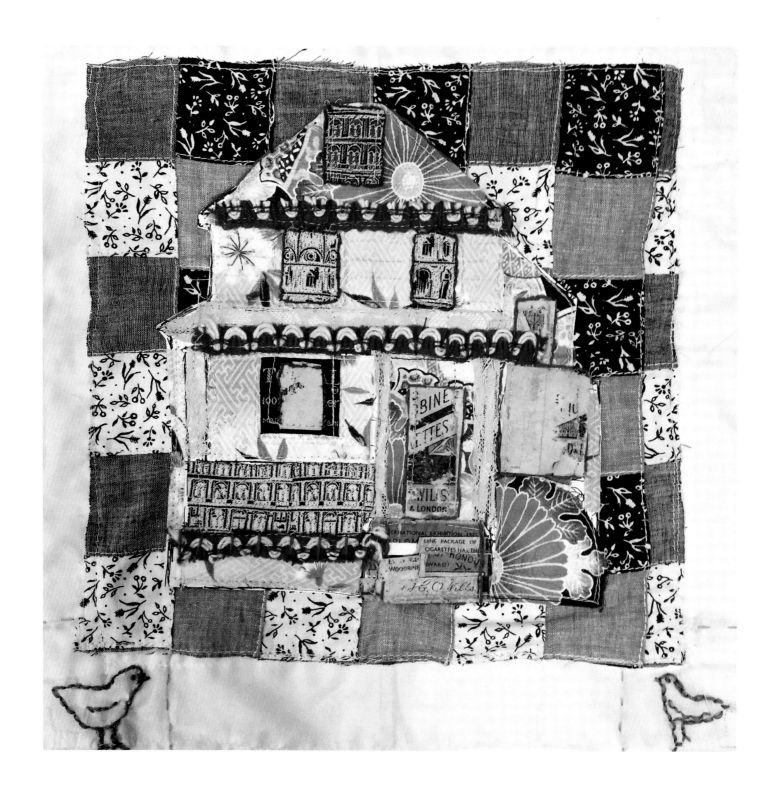

Making a Scrap Collage

MATERIALS AND EQUIPMENT

» Paper and pen or pencil

» Paper, scissors and sewing scissors

» Strong fabric (linen, cotton canvas or calico are ideal) for the background, 25 x 25cm (10 x 10in)

» Scraps of fabric, embroidery and labels (not too much stretch)

» Pins

» Glue stick

» Machine and hand-stitching thread

» Items for embellishment (buttons, ribbon and so on)

1 Begin by drawing your house (or other feature) on paper as a basic outline drawing, with no major details, making clear lines that you will be able to cut out.

2 Ensure that it fits well inside your background fabric.

3 Cut out the pieces of the house using paper scissors and pin to pieces of fabric, embroidery and labels.

4 Using fabric scissors cut out the pieces of the house.

5 Arrange the pieces of the house on the background, and then pin or glue with a light coating of glue stick.

6 Tack the house pieces onto the background. Use a mixture of machine and hand stitching – this will make your piece much more interesting.

7 When you have completed the house, you can decide what you want to do with the background – whether you want to include foliage, a fence or a path, for example.

8 Now you are ready to embellish your piece using ribbon, buttons and some embroidery. My piece used a mixture of stitches, including backstitch, French knots and blanket stitch.

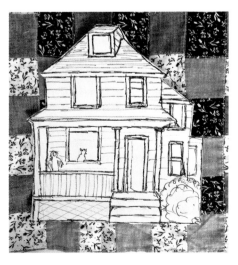
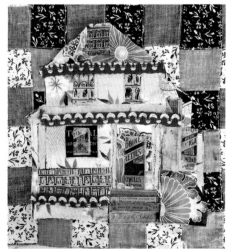

Dutch Houses

When visiting Amsterdam, I was inspired by the houses lining the canals. I made several drawings of them and transferred them onto fabric when I returned to the studio. I was also inspired by pages from this vintage book on Dutch cross stitch (shown opposite).

Dutch River House, mixed-media textile with lace, embroidery and printed textile collage.

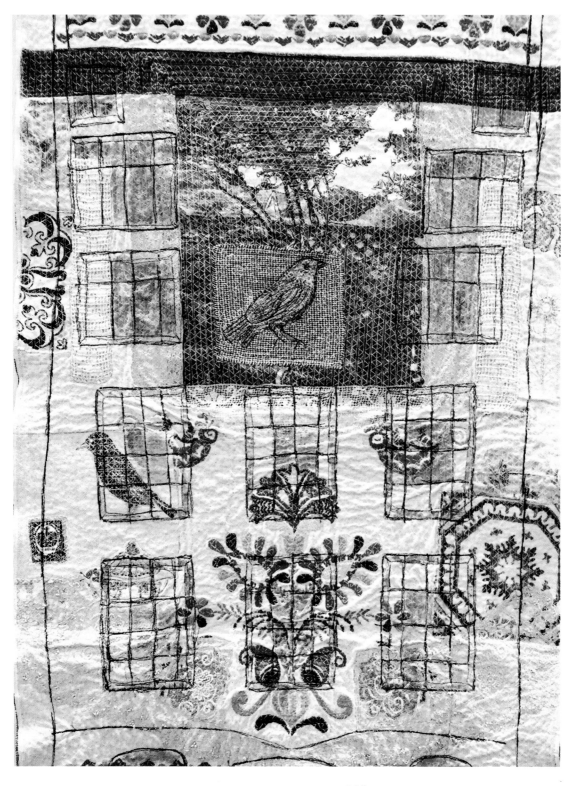

In a vintage shop in Margate, Kent, I found the lovely felt collage shown below, which came from the Netherlands. It has shapes and objects cut out and stitched on the background. It was conceived as an advert for the Hoover company and is signed by the artist.

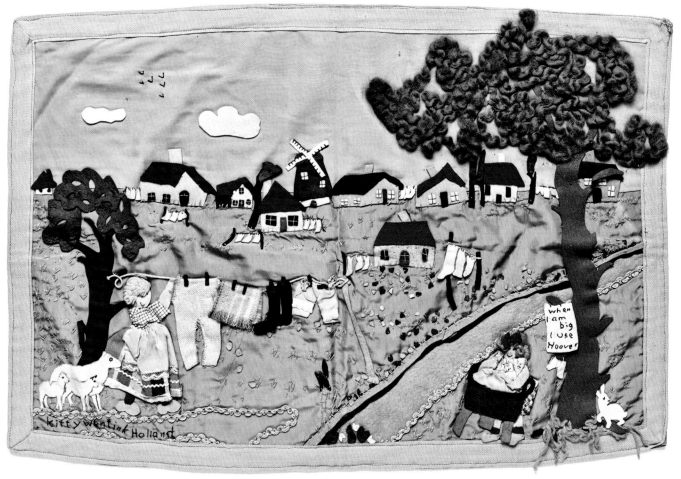

Carolyn Saxby

Carolyn is based in Cornwall and much of her work is inspired by many aspects of St Ives. Her work observes landscape and seascape and her love of nature, exploring the tones and textures of her surroundings. In *St Ives Cottages*, Carolyn used heated and painted backgrounds on cotton linen. She uses shells, real seaweed and lots of hand stitching as well as painted and manipulated surfaces to create further texture. In *Of Sea and Sky*, she again used found and melted fabrics embellished with a tiny row of Alfred Wallis-inspired cottages. Fabrics have been textured and frayed to convey depth and movement.

Of Sea and Sky, a mixed-media textile, and *St Ives Cottages* (inset), both by Carolyn Saxby.

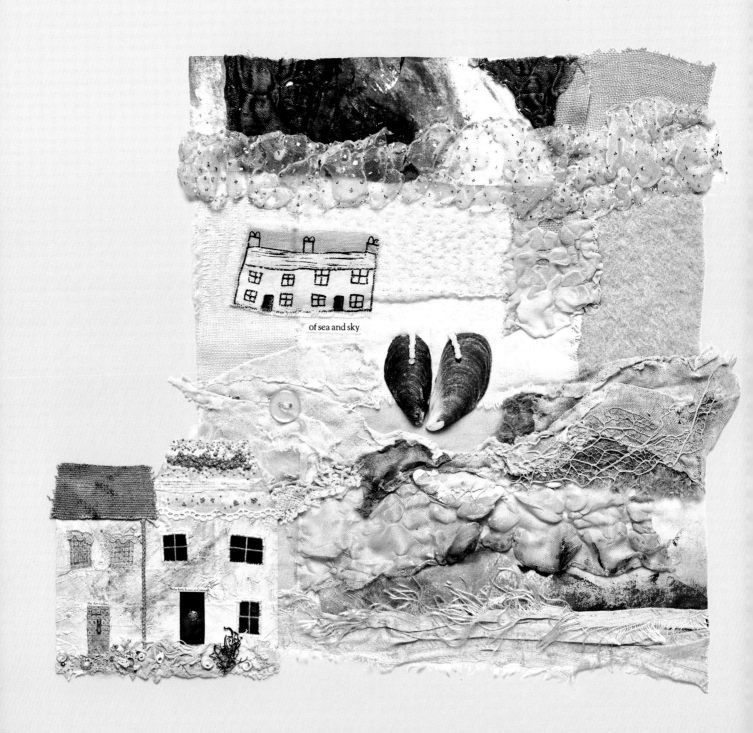

Martine Apaolaza

I exhibited with Martine in Beaujolais and was much taken by her beautifully stitched collages of life in rural France, often featuring houses. She recently exhibited at the Festival of Quilts in the UK and this piece, *Honfleur*, was shown there. Martine says:

'The works that are very recent emerged from a journey to Normandy that breathed new life and expression into them. I mostly use linen and cotton, and the combination helps to create a spontaneous and creative effect'.

Honfleur, mixed-media textile by Martine Apaolaza.

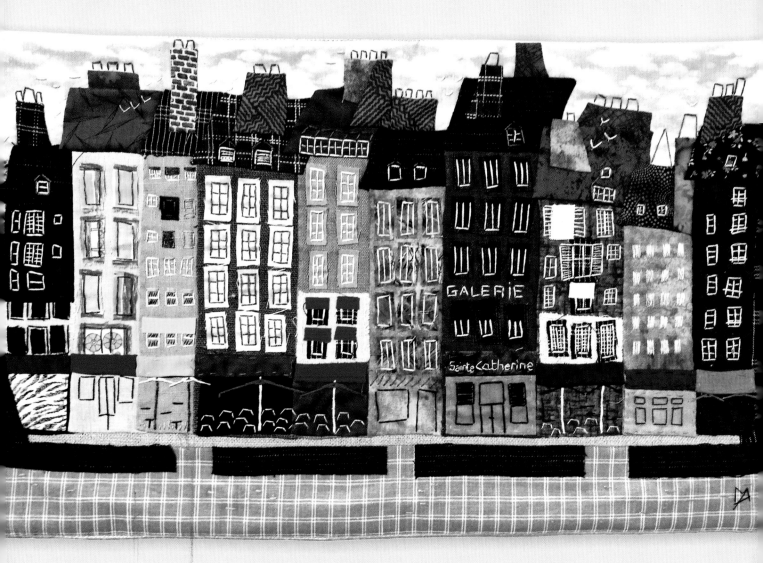

Adding Meaning
with Garments

When teaching in Australia I became aware of an ongoing project culminating in an exhibition at the Lock-Up Gallery in Newcastle, near Sydney, Australia. *Stitched Up* looked at the lives of the 193 girls sent to the Newcastle Industrial School, 150 years after the school's opening. It was curated by Anne Kempton, Creative Director of the Timeless Textiles Gallery, and fibre artist Wilma Simmons. The exhibition featured 24 internationally renowned fibre artists from Canada, the Netherlands, the UK, Denmark and around Australia responding to the lives of the girls.

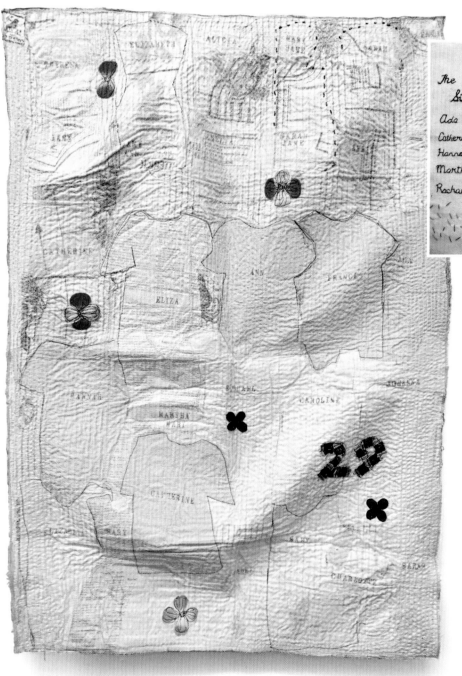

Left: *29 Sisters*,
mixed-media textile.

Above: *Untitled*, piece for
the *Stitched Up* exhibition,
mixed-media textile by
Wilma Simmons.

I read some documentary evidence about the girls and wanted to capture the groupings of sisters at the school. Using remnants of the fabric that I had brought and pieces donated by the gallery, I created small dress patterns to represent the girls who were sisters and printed their names on the background. My signature of stitching across the entire piece with an edging stitch was used to finish the piece, which was backed with a printed pattern cloth found in Australia.

Using Clothing

Many artists and folk traditions include garments as part of their narrative, as they carry the designs and marks that represent their tradition well. There is a long history of such items in almost every country in the world. My love of these garments has found its way into my recent work. Handling the garments and using sections of them in new pieces helps you to appreciate the work that went into their making and reusing and re-purposing them brings them to life again.

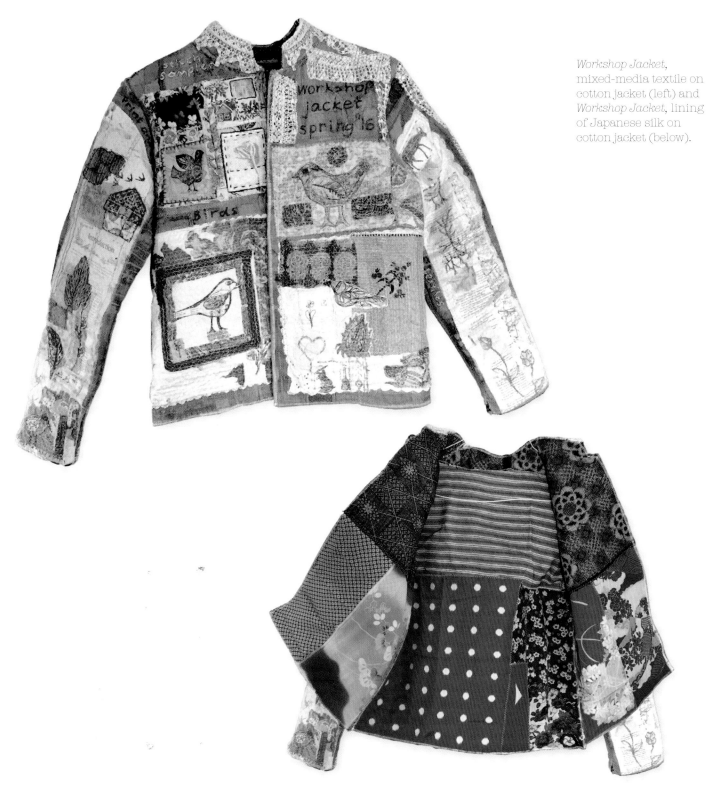

Workshop Jacket, mixed-media textile on cotton jacket (left) and *Workshop Jacket*, lining of Japanese silk on cotton jacket (below).

Waistcoat Garden Quilt

I started collecting waistcoats I found in charity shops, especially those that had interesting patterns on the front. I found that they made a good background on which further items could be appliquéd. I also found a lovely old patchwork quilt in a log-cabin design of autumnal colours. I used it as a background to frame the waistcoat pieces. This photo was taken in my garden. It was first shown at the Knitting and Stitching Shows in London, Dublin and Harrogate in 2016. Each waistcoat is reminiscent of a different place or theme.

Waistcoat Garden Quilt, mixed-media textile.

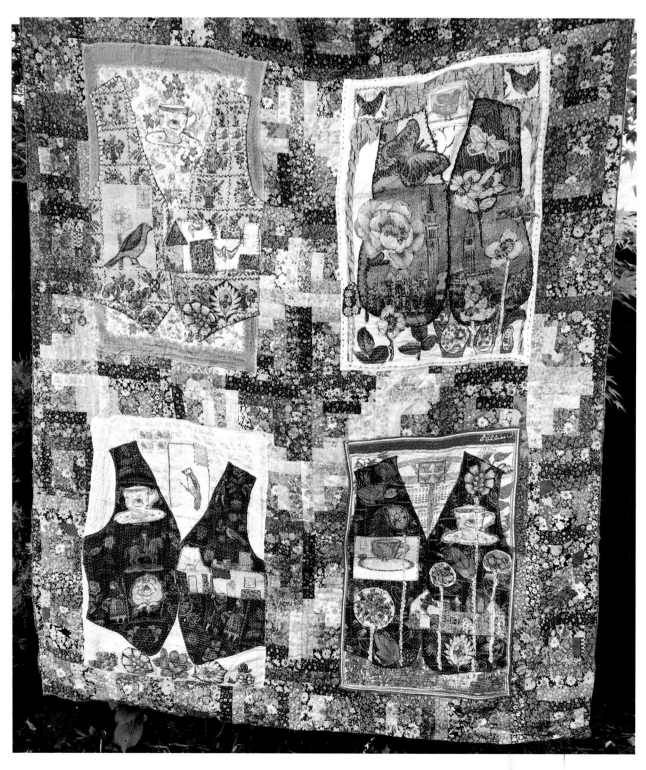

Diane Savona

Diane Savona uses the lace and embroidery of her ancestors to create her multi-layered and distinctive work. She says:

'My quilts are made almost entirely of used materials. Old cloths, buttons, sewing tools and stories (collected at garage and estate sales) connect my work to the people in my community, both past and present. These quilts are intergenerational collaborative efforts, with anonymous old ladies supplying the crocheted and embroidered cloth. Ancient images are sometimes preserved in textile arts, and these images strongly influence my work. History on a very personal level – in the context of household items and old clothing – is sewn into the tale of women's textile traditions. My grandmother emigrated from Poland, and I am devoted to finding, saving and honouring the rapidly vanishing hoards of old handworked linens from the women of her generation.'

Diane Savona, *Fossil Garment Number 2*, mixed-media textile.

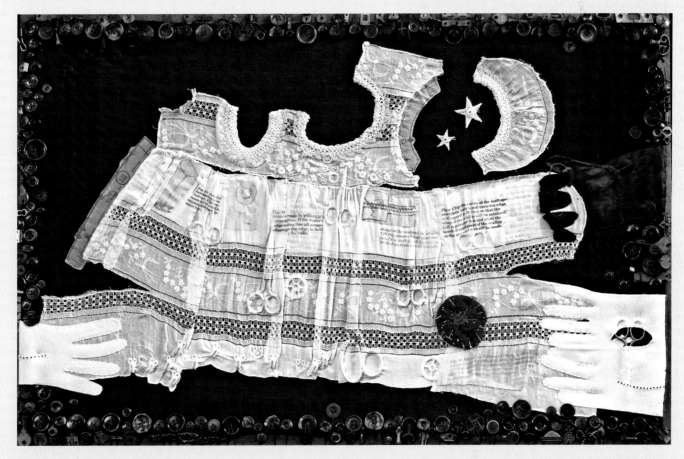

Diane Savona, *Fossil Garment Number 7*, mixed-media textile.

Ancestors

Zulema Alma is a piece about my maternal grandmother, who was a great needlewoman, and I have used an example of her tapestry work (an owl) as a focal feature. It is integrated with an item of clothing. Sections of lace (also from my grandmother) and some hand stitching complete the piece. It was first shown at the World of Threads Festival in Canada, as was *Sophie Bianca*, a piece about my paternal grandmother (shown opposite).

Zulema Alma, mixed media with lace, ribbon and needlework fragment on linen cloth.

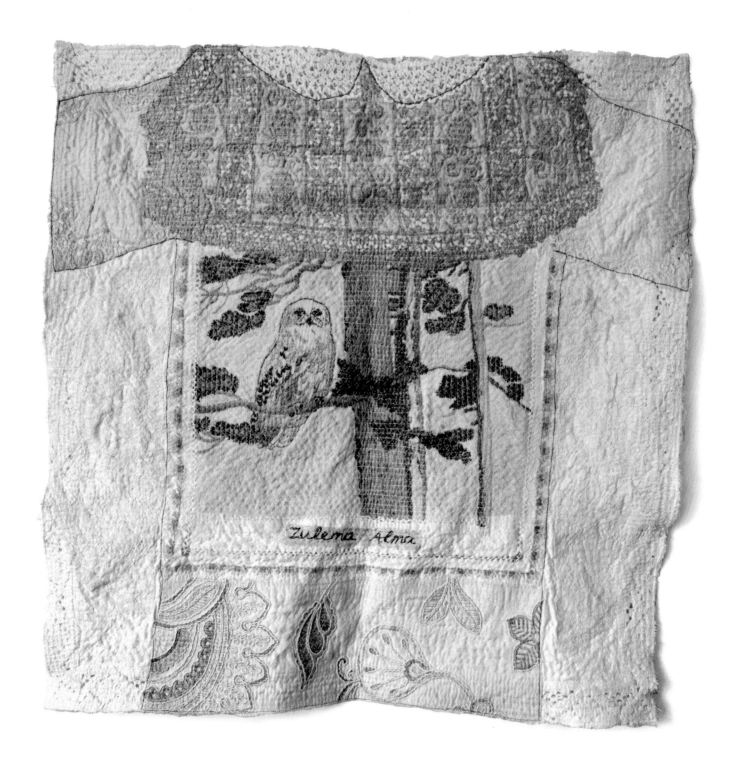

Sophie Bianca, mixed media with lace, ribbon, beads and vintage textile on linen cloth.

Sophie Bianca was my paternal grandmother. She grew up on the French border in Germany and fled to England with her family as a refugee in 1938. She was part of an upper middle class family and appreciated fashion and textiles. Her piece has a fragment of German embroidery worked into it, with textiles found in a charity shop in Berlin.

Folk Installations:
Caitlin Hinshelwood

Caitlin is a London-based textile artist and designer producing hand-dyed and screen-printed artworks. She says:

'Within my practice I am interested in the narrative possibilities of textiles: how textiles can be used to communicate and how they can act as repositories of personal or social history. In recent years I have created more large-scale pieces to explore these themes, using motifs and symbols to suggest narratives or tell untold histories. The large-scale works acknowledge the existing visual language of banners and flags, reimagining historical references in a contemporary way.

'I am often drawn to folk art and ethnographic collections for my inspiration. I enjoy how an apparently naïve piece can sometimes belie its inherent craftsmanship. I am attracted to works and objects often made by unknown makers that have been created for the love of making, for necessity, for decoration but that somehow hold something of the maker or community or some tradition or story.'

Recently Caitlin has created a series of 11 large-scale silk banners for a solo show 'Kissing the Shuttle', at Cecil Sharp House. She developed these banners in response to research carried out at the Vaughan Williams Memorial Library, the People's History Museum and the Working Class Movement Library. The banners highlight the creative role of women in historic textile industries, primarily in Northern England and Northern Ireland. They explore themes of resistance, community, visual communication, industrial folklore and folk practices.

Mee Maw and *Lavender Ceremony Flag*, silk printed textiles by Caitlin Hinshelwood.

Folk Installations:
Forest + Found

Forest + Found is the working and exhibiting partnership of Max Bainbridge and Abigail Booth. Based in East London, their work is:

'… based on architectural structures, ancient landscape and cultural objects. They are both trained in fine art and their approach to practice is investigative and research driven, stemming from a deep relationship to object making. The traditional skills they employ are tools for questioning how, through the use of natural materials and hand tools, they can gain a greater understanding of our strong connection to place through the experience of making and handling objects. Hand carving, wood turning, natural dyeing and textile construction are used for exploring the sculptural and performative quality of objects, through form, composition and colour. Working with native wood and a dye palette sourced from the land, their practice is driven by process and a generated dialogue between the objects and textiles they make. Mark making and the meaning of the made object is looked at across all times and cultures.'

This allows them to make work that bridges the past, present and future.

Forest + Found,
Unearthed View 1.

Forest + Found,
Unearthed View 3.

Stitched Shed

I came up with the idea for a stitched shed when I was given a stand at the Knitting and Stitching Shows in London, Harrogate and Dublin. I wanted to create a focal point as I knew from experience that visitors liked to have something new and original to look at. I investigated all kinds of sheds and outbuildings, and even considered making one. However, it was serendipitous that on a visit to Sussex Prairie Garden during my artist's residency in October 2015, the owner, Pauline, offered to lend me their purpose-built shed on wheels.

I used that winter as an opportunity to clean, repaint and cover the shed, with some help from friends and the volunteers at Sussex Prairie Garden. After the shed was painted white, I was able to start to re-cover it. First I used old maps and pages from a book of flowers to cover the roof. Then I used pieces of fabric and embroidery from my collection to cover one side, around the window. On one end I used the bunting from my residency at Sussex Prairie Garden, *A Natural History of the Garden*, which was cut to fit around the door. The fourth side was covered with pieces from an installation, which were cut up and re-purposed. The inside of the shed was finished with hessian and needed some recovering and stapling.

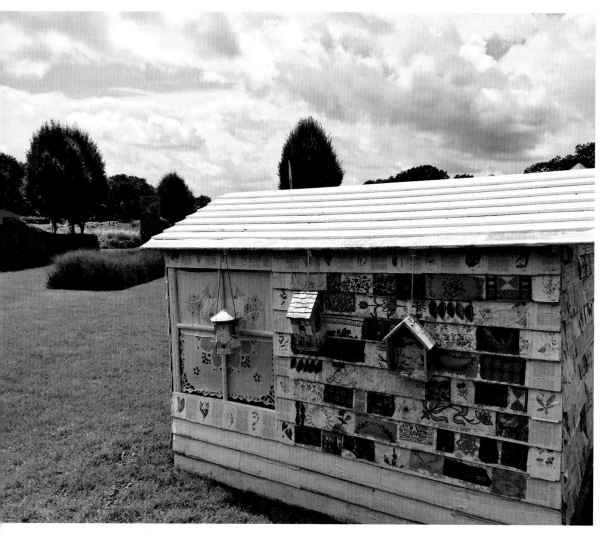

Stitched Shed, Sussex Prairie Garden, mixed media on wood shed.

Stitched Shed at the Knitting and Stitching Show

As the shed could be dismantled and was mounted on wheels, it was relatively easy to transport. It was taken from Sussex Prairie Garden to London, Dublin and Harrogate. The exhibition inside was a series of work that I completed while I was artist in residence at the garden. It was entered and enjoyed by the visitors to the show.

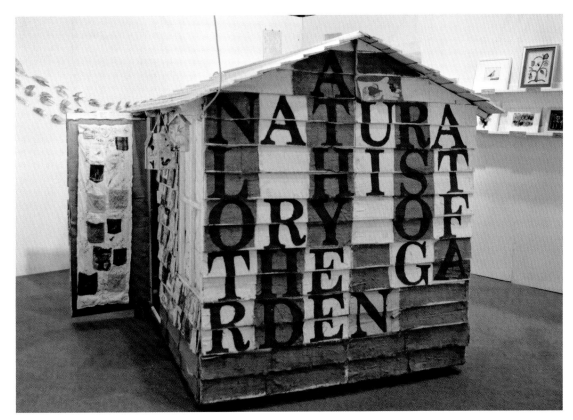

Stitched Shed, Knitting and Stitching Show, mixed media on wood shed.

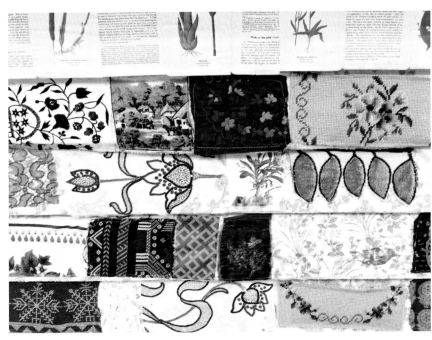

Stitched Shed (detail), mixed media on wood shed.

Conclusion

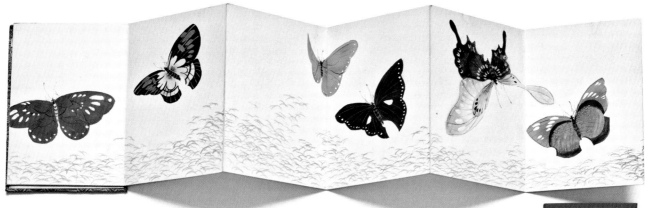

My goal in writing this book is to highlight some of the everyday, simple and folk influences that can inspire textile artists. In our digital age an honest aesthetic can be overshadowed by more polished imagery. Learning by linking seeing to making marks has become even more important and valuable and it is what makes handmade work so distinctive.

I have also become aware as an immigrant to my adopted country of the importance of sharing our heritage and traditions from all nations. That diversity and openness is what continues to make London such a great city. My father's family were refugees and my project *Moving Memories*, highlighted in the book, is a tribute to their journey to safety.

I am very thankful to all of the artists, makers, companies and institutions that have generously allowed the reproduction of their images and words. My teaching continues to inform my practice with the connection to my students and their ideas and experience. I have been touched by the response to *Textile Nature* abroad and hope that this book will be enjoyed similarly.

My family and friends continue to travel with and support me and perhaps aren't always aware of how much I appreciate it. My husband's unwavering faith and enthusiasm in my practice was something to behold when he was encouraging hesitant visitors to enter the Stitched Shed at the Knitting and Stitching Shows. 'You've never been inside a stitched shed? Why not?'

Finding a still, quiet place to stitch (wherever it may be), in this ever-busy and complicated world is a gift and to be treasured. I hope that this book will inhabit that space with its readers.

This page: Butterflies from the author's collection.

Opposite: *White Dress Too*, mixed-media textile.

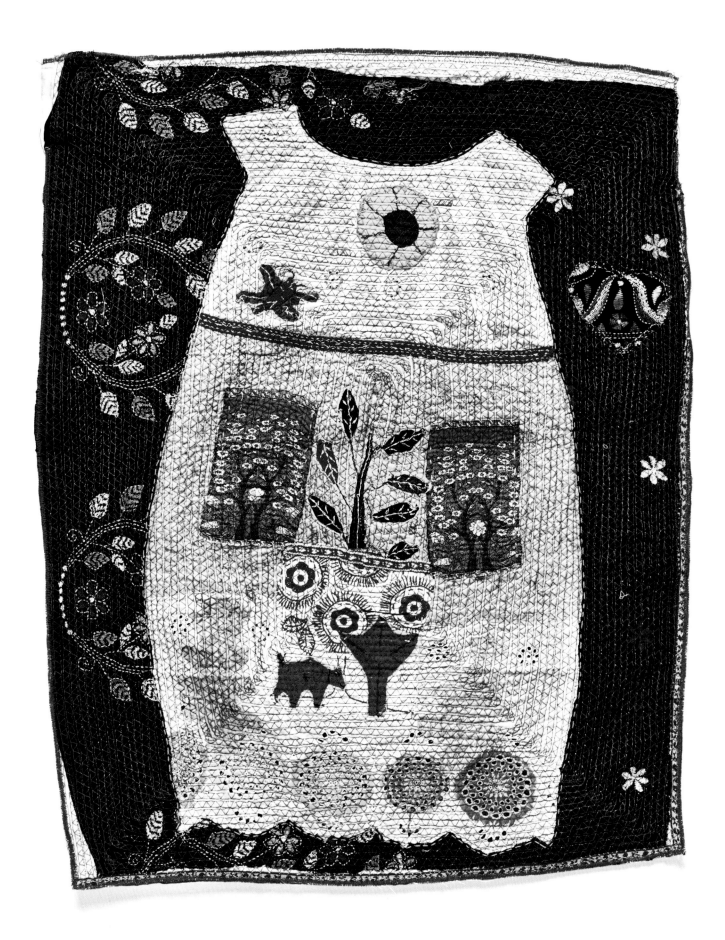

Featured Artists

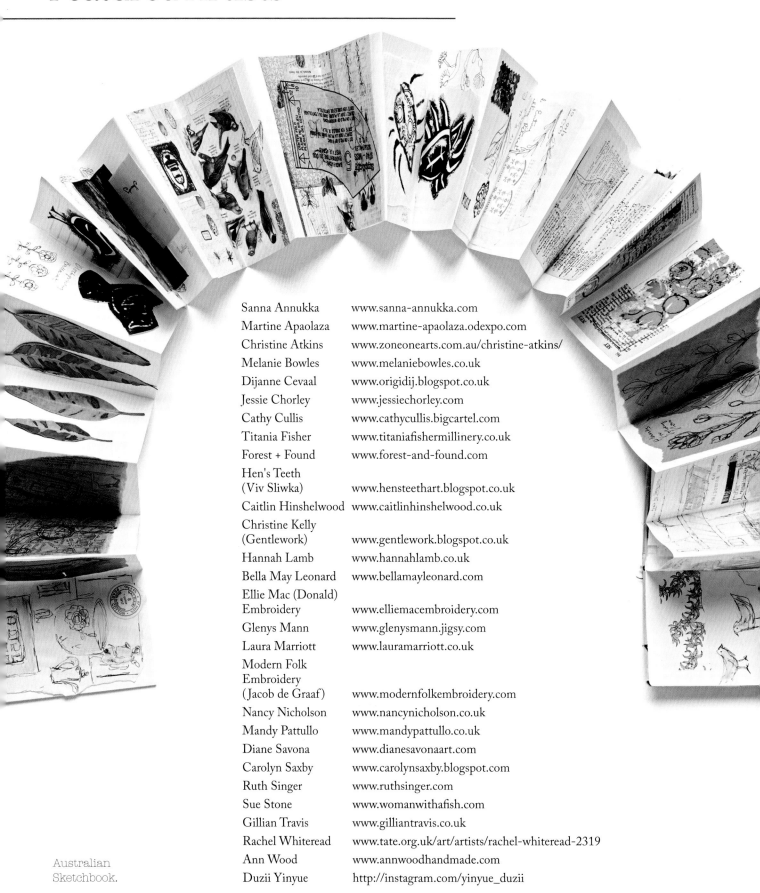

Sanna Annukka	www.sanna-annukka.com
Martine Apaolaza	www.martine-apaolaza.odexpo.com
Christine Atkins	www.zoneonearts.com.au/christine-atkins/
Melanie Bowles	www.melaniebowles.co.uk
Dijanne Cevaal	www.origidij.blogspot.co.uk
Jessie Chorley	www.jessiechorley.com
Cathy Cullis	www.cathycullis.bigcartel.com
Titania Fisher	www.titaniafishermillinery.co.uk
Forest + Found	www.forest-and-found.com
Hen's Teeth (Viv Sliwka)	www.hensteethart.blogspot.co.uk
Caitlin Hinshelwood	www.caitlinhinshelwood.co.uk
Christine Kelly (Gentlework)	www.gentlework.blogspot.co.uk
Hannah Lamb	www.hannahlamb.co.uk
Bella May Leonard	www.bellamayleonard.com
Ellie Mac (Donald) Embroidery	www.elliemacembroidery.com
Glenys Mann	www.glenysmann.jigsy.com
Laura Marriott	www.lauramarriott.co.uk
Modern Folk Embroidery (Jacob de Graaf)	www.modernfolkembroidery.com
Nancy Nicholson	www.nancynicholson.co.uk
Mandy Pattullo	www.mandypattullo.co.uk
Diane Savona	www.dianesavonaart.com
Carolyn Saxby	www.carolynsaxby.blogspot.com
Ruth Singer	www.ruthsinger.com
Sue Stone	www.womanwithafish.com
Gillian Travis	www.gilliantravis.co.uk
Rachel Whiteread	www.tate.org.uk/art/artists/rachel-whiteread-2319
Ann Wood	www.annwoodhandmade.com
Duzii Yinyue	http://instagram.com/yinyue_duzii

Australian Sketchbook.

Folk Art Collections, Museums, Institutions and Organizations

Almgrens Sidenväveri
and Museum
(silk weaving) www.kasiden.se

Berry Quilting
Retreat www.berryquiltingretreat.com.au

Embroiderers' Guild www.embroiderersguild.com

Fibre Arts Australia www.fibrearts.jigsy.com

Fibre Arts
New Zealand www.fibreartsnz.co.nz

Fitzwilliam Museum,
University
of Cambridge www.fitzmuseum.cam.ac.uk

Hand and Lock www.handembroidery.com

Jacques and Catherine
Legeret quilts www.quiltsamish.com

Jewish Museum
London www.jewishmuseum.org.uk

Knitting and
Stitching Show www.theknittingandstitchingshow.com

Linladan www.linladan.com

National Needlework
Archive www.nationalneedleworkarchive.org.uk

Nordiska Museet www.nordiskamuseet.se

Svenskt Tenn
– Josef Frank fabric www.svenskttenn.se

Timeless Textiles www.timelesstextiles.com.au

V&A Museum
of Childhood www.vam.ac.uk/moc/

Wooden Horse
Museum www.woodenhorsemuseum.se

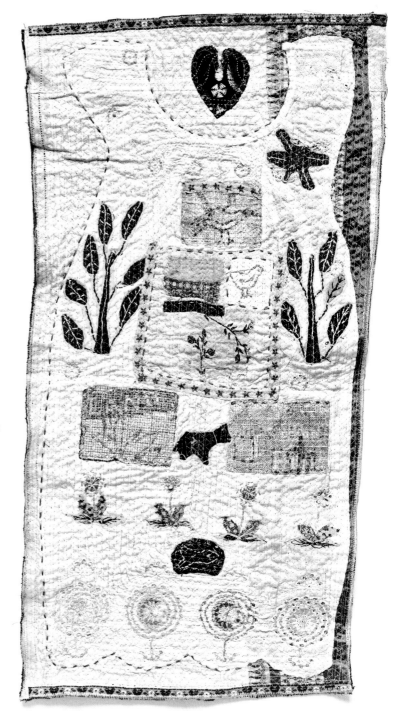

White Dress,
mixed-media textile.

Further Reading

Corrigan, Gina, *Miao Textiles from China* (Fabric Folios) (The British Museum Press, 2001)

Hergert, Anna, *Inspiration Kantha: Creative Stitching and Quilting with Asia's Ancient Technique* (Schiffer Publishing, 2017)

Holmes, Cas and Kelly, Anne, *Connected Cloth* (Batsford, 2013)

Humphrey, Carol, *Sampled Lives* (Fitzwilliam Museum, Cambridge, 2017)

Jarrett, Joy and Scott, Rebecca, *Samplers* (Shire Publications, 2009)

Kelly, Anne, *Textile Nature* (Batsford, 2016)

Noble, Marty, *European Folk Art Designs* (Dover Pictorial Archive, 2004)

Nicholson, Nancy, *Modern Folk Embroidery* (David and Charles, 2016)

Pattullo, Mandy, *Textile Collage* (Batsford, 2016)

Warren, Elizabeth V with Gordon, Margaret, *Red and White Quilts: Infinite Variety, Presented by the American Folk Arts Museum* (Skira Rizzoli, 2015)

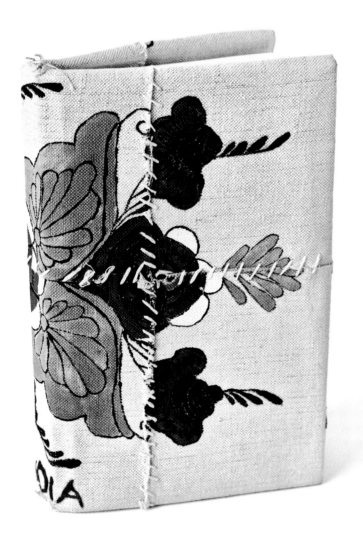

Russian Doll,
Reduction lino
print on paper.

Suppliers

Here is a selected list of suppliers in the UK, North America and Australia.

UK

George Weil
Old Portsmouth Road
Peasmarsh, Guildford
Surrey GU3 1LZ
Tel: 01483 565800
www.georgeweil.com

Seawhite
Avalon Court, Star Road Trading Estate
Partridge Green, Horsham
West Sussex RH13 8RY
Tel: 01403 711633
www.seawhite.co.uk

Colouricous Block Printing and Holidays
Office 7, Eclipse House
20 Sandown Road, Watford
Hertfordshire WD24 7AE
http://colouricious.com

Art Van Go
The Studios
1 Stevenage Road
Knebworth
Hertfordshire SG3 6AN
Tel: 01438 814946
www.artvango.co.uk

Bernina UK
91 Goswell Road
London EC1V 7EX
Tel: 020 7549 7849
www.bernina.com/en-GB/
Home-United-Kingdom-Ireland

Canada and USA

Textile Museum of Canada Shop
55 Centre Avenue
Toronto, ON
M5G 2H5
Canada
Tel: 1-416-599-5321
www.textilemuseum.ca/shop/tmc-shop

PRO Chemical and Dye
126 Shove St
Fall River
MA 02724
USA
Tel: 1-800-228-9393
www.prochemicalanddye.net

Australia

Opendrawer
1158 Toorak Rd, Camberwell
VIC 3142
Tel: (61) 3 9889 7227
www.opendrawer.com.au

The Thread Studio
6 Smith Street
Perth, Western Australia 6000
Tel: (61) 8 9227 1561
www.thethreadstudio.com

Detail of *Travel Box*
(see pages 14–15).

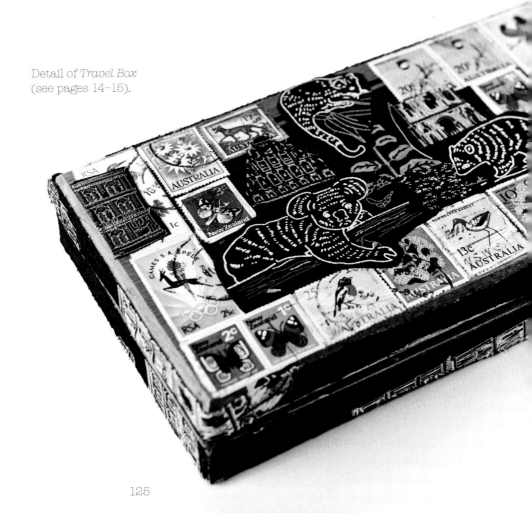

Index

A
Apaolaza, Martine 109
Annukka, Sanna 36
Arks 28, 29
Atkins, Christine

B
Badges 83–87
Bags 66, 67
Benjamin, Doris 84
Beverley, Deena 103
Birds 88–91
Bowles, Melanie 68
Box
 Sewing 25
 Travel 14, 15
Buglife 56
Bugs 55, 56

C
Cevaal, Dijanne 58
Chorley, Jessie 20, 21
Church Installations 22, 23
Commission 98, 99
Cullis, Cathy 71

D
Dala Horses 36
de Graaf, Jacob 12
Derow, Mary 11

E
Embroiderers Guild 91

F
Fibre Arts Australia 80, 81
Fibre Arts New Zealand 81
Fisher, Titania 69

Fitzwilliam Museum 11
Folding Books 64, 65
Folk Art
 Bulgarian 69
 Collages 37, 78, 79
 Flag 48, 49
 Indian 62, 63
 Motifs 57
 Portraits 70, 71
Forest + Found 117
Frank, Josef 42, 43

G
Garments 110–115
Gentlework 24

H
Haberdashery 25
Hand and Lock 85
Hen's Teeth Art 13
Hinshelwood, Caitlin 116
Houses
 Collage 104, 105
 Dolls 102
 Dutch 106, 107
 Inspiration 101
 Wooden 38

I
India 62, 63
Inner Mongolia 62, 63

J
Jewish Museum, London 84

K
Kelly, Christine 24

L
Lamb, Hannah 18, 19
Legeret, Jacques collection 95
Lettering 16, 17
Leonard, Bella Mae 57
Linladan, 36

M
Macdonald, Ellie 86
Mann, Glenys 59
Marriott, Laura 83, 87
McBride, Pauline 16

N
National Needlework Archive 100
Nicholson, Nancy 74, 75
Nordic Design 32, 36
Nordiska Museet 33

P
Pattullo, Mandy 40, 41
Pincushions 26, 27

Q
Quilts 95, 97

S
Samplers 8, 10,
 Contemporary 12
 Historical 11
 Lettering 17
Savona, Diane 113
Saxby, Carolyn 108
Screen Printing 46, 47
Shed, Stitched 118-119
Simmons, Wilma 110
Singer, Ruth 27

Sliwka, Viv 13
Stone, Sue 71
Suitcases 60, 61
Svenskt Tenn, 42, 43

T

Thurell, Katarina, 83
Timeless Textilea 110
Travel Tags 60

Travis, Gillian 39
Tree of Life, 74, 76, 77

V

Victoria and Albert Museum of
Childhood 101

W

Westman, Asa 34

Whiteread, Rachel 101
Wood, Ann 97
World of Threads Festival 115, 116

Y

Yinyue, Duzi 55

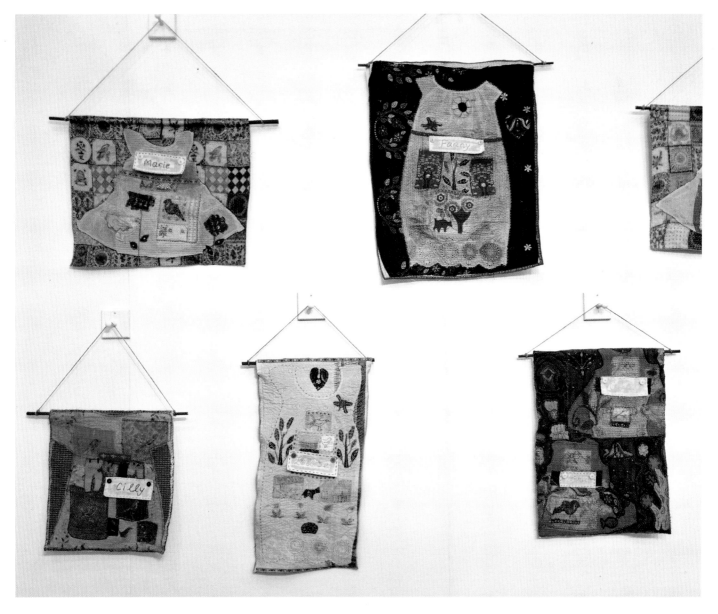

Picture Credits

Photography by Rachel Whiting and the author, with the exception of the following:

Christine Atkins page 77; Melanie Bowles page 68; Dijanne Cevaal page 58; Jessie Chorley page 21–22; Cathy Cullis page 71 (bottom); Jacob de Graaf page 12; Titania Fisher page 69; Fitzwilliam Museum, Cambridge © University of Cambridge page 11; Forest + Found page 117; Gentlework (Christine Kelly) page 24; Hen's Teeth (Viv Sliwka) page 13; Caitlin Hinshelwood page 116; Hannah Lamb page 18–19; Jewish Museum, London page 84; Bella May Leonard page 57; Ellie Macdonald page 86; Glenys Mann page 59; Laura Marriott page 87; Nancy Nicholson page 74–75; Mandy Pattullo page 40–41; Diane Savona page 113; Ruth Singer page 27; Sue Stone page 71 (top); Svenskt Tenn page 42–43; Gillian Travis page 39; Asa Westman page 35; Ann Wood page 97.

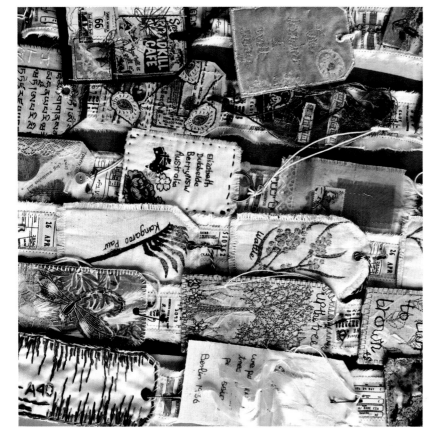

Travel Tags by various makers, for the Knitting and Stitching Show at Olympia in London (see also pages 60-61).